Past Times of Macclesfield

Volume III

Dorothy Bentley Smith

AMBERLEY

Dedicated to the memory of Jean Ellis (1948–2010).

Ignorance is the first requisite of the historian—
ignorance, which simplifies and clarifies,
which selects and omits, with a placid perfection
unattainable by the highest art.
Lytton Strachey
1880–1932

First published 2016

Amberley Publishing, The Hill, Stroud
Gloucestershire GL5 4EP

www.amberley-books.com

British Library Cataloguing in Publication Data.
A catalogue record for this book is available from the British Library.

ISBN 978 1 4456 5821 6 (print)
ISBN 978 1 4456 5822 3 (ebook)

Typesetting and Origination by Amberley Publishing.
Printed in Great Britain.

Contents

Author's Note

During the fourteen years in which I wrote for the newspaper I always received great encouragement from Jean Ellis, both before and after she become editor. Her enthusiasm and dedication were second to none. Not only was she keen on local history, but her commitment to photography and also her unbiased straightforward reporting were appreciated by all who knew her.

When Jean died so did the newspaper and with it I, among many, lost a great and professional colleague. It seemed appropriate, therefore, that I should dedicate this book to her; it has also allowed me the opportunity to express my gratitude for so many personal kindnesses received from a very special person.

Late in the summer of 1994 Granville Sellars, then the owner of the *Macclesfield Community News*, offered me the opportunity to write a series of local history articles for the free monthly newspaper. I eagerly accepted, but neither he nor I could have envisaged the considerable response that would allow me to continue producing new information on the history of the town and area for so many years; so to him must go my first vote of thanks.

I can only reiterate most of what I have previously stated. It has been a fascinating and rewarding journey made possible, not only by the Macclesfield people of the past, but also those of the present who have helped in several ways. Many have generously given permission for property deeds to be examined; produced old books, long since removed from accessible bookshelves; donated photographs and information, and invited me into their homes.

My sincere thanks must go particularly to Mr Johnny Van Haeften for allowing inspection and reproduction of information from his large collection of uncatalogued Brocklehurst deeds. Details from this collection have been used extensively in the text for several properties in and around the Macclesfield area.

I am also indebted to numerous solicitors; estate agents; personnel within banks, breweries, head offices of businesses investing in High Street shops; the Macclesfield Borough Council and the Silk Heritage Centre, for their co-operation. Nor must the staff of the Cheshire County Record Office and Macclesfield Public Library be forgotten, who have been indefatigable in searching out relevant sources of information. The staff of Mailboxes have given considerable assistance with illustrations over the years in reproducing specific details from photos and plans, not only in connection with my writings, but also in understanding my specifications in relation to material for numerous exhibitions.

And last, but by no means least, my thanks must go to the excellent 'team' in the then *Community News* offices, and in particular to the editor, Jean Ellis, for whom a special dedication is necessary.

This third book completes my fourteen years as a columnist and historian with the *Community News* before being invited to write for the *Macclesfield Express*.

As previously stated, it is inevitable when writing for a newspaper that occasions will arise when editing takes place, or photographs and even articles omitted, because of limited space. This has given me the opportunity to correct errors where necessary, and also add additional information and illustrations. I sincerely hope that this book will not only be of interest as a general read, but will also be used for research purposes and encourage a further generation to appreciate the wealth of history that lies within the town and environs of Macclesfield, which, for almost 750 years, people were proud to call the manor, forest and borough.

West Park

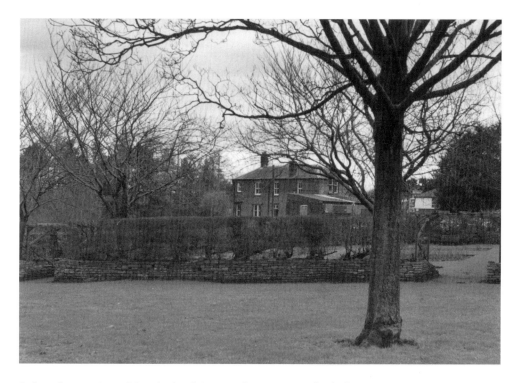

Before the creation of Cumberland Street, what remains of Whalley Heyes Lane continued into the original Prestbury Lane along what is now the western end of Cumberland Street. As late as 1850 it passed through gardens and fields, with the land on its northern side owned mostly by the Free Grammar School and certain individuals very much involved in the civic life of the borough.

At this time public parks were appearing in many of the northern cities and John May, who had been articled to the town clerk and subsequently become an important legal figure in Macclesfield, proposed a public park for the town.

The idea was greeted with enthusiasm, but there were two main obstacles *viz*: the appropriate location and whether or not the landowners in the chosen area could be persuaded to sell the necessary land.

Subscriptions were soon forthcoming from the working classes, but it took another four years of behind-the-scenes activities to complete the initial transaction, which then led to large donations from some of the wealthier merchants of the town.

On 19 April 1854 the mayor, John Smith and John May, on behalf of the Corporation, bought from Richard Wright (a burgess and former mayor of 1847–48) three plots of land. These adjacent plots were originally part of the town field and totalled about 11 acres. They lay along the eastern side of Prestbury Road with an entrance and a proposed road of 12 feet in width leading from Prestbury Road to Westbrook(e) House and what remained of its surrounding land.

The layout of the road was to be between the northern end of where the museum now stands, and the entrance to the cemetery. This 11 acres was the original park, but access to house and park were created as seen today.

It opened to the public in October 1854 during Wakes Week with a spate of celebrations, and was bounded by the Westbrook Estate on the east; a small portion of the town field and part of Orme's Croft, on the Whalley Heyes [sic] side and by 1856 the new public cemetery on the north.

Origins

The whole of West Park today was originally claimed by the medieval burgesses as a town field. By 1710 it was owned by Rowe Deane, mayor of Macclesfield 1707–08, a burgess whose family had provided six terms of duty as town mayors during the seventeenth century. How it came into his possession is a mystery, but, during the Commonwealth period, the Corporation was selling off some of its assets, which conveniently seem to have passed into the hands of one or two of its burgesses.

This Deane estate subsequently passed through several hands and a house was built on the land, but the date is unknown. Although let at times, Rowe Deane had made a covenant of 5s 3d to be paid to the poor of the borough forever. This came under the auspices of the parish church and actually lasted until 1996, when legislation allowed for the right to be relinquished in view of the incredibly insignificant value by then.

However, by the beginning of the nineteenth century Charles Wood had gained possession of the land. He was involved in the cotton business with Ryle and Daintry at Sutton Mills, Mill Green, Macclesfield. The acquisition was used as collateral, enabling Wood to obtain a loan of £5,000 from a Revd William Yates, rector of Eccleston in Lancashire. Unable to repay the loan and interest Wood was forced to convey his acquisition to Revd Yates.

Around this time, Yates must have been responsible for the creation of the house, buildings, croft and gardens, which were named the Westbrook Estate after the name given to the house. It was subleased to a tenant, John Stancliffe, and subsequently to a Richard Wright. Revd Yates died on 26 October 1848 and Richard Wright bought the estate from the executors.

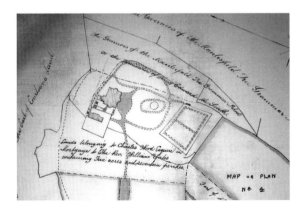

Plan of Westbrook House circa 1820. Home of Charles Wood 1818–26.

On 22 September 1852 the governors of the grammar school entered into an agreement with Richard Wright to buy the mansion called 'Westbrook House' with the yard, croft and gardens; the latter including a well-kept kitchen garden, originally forming part of an area known as the Longlands and Orme's Croft, for the headmaster. However, before the sale was completed, early in 1853 Wright put the property up for sale by public auction and divided it into four lots – the money was to be paid before December.

Three of these lots were, of course, sold to the Corporation during April, and probably the fourth should have been included, but the governors acted quickly and during the same month filed a petition in the High Court of Chancery referring to two Acts of Parliament that had given the school more legal rights. The governors, therefore, requested permission to complete the contract and convert Westbrook House into a residence for the headmaster of the school. By a court order of the vice chancellor of the court, dated 10 June 1854, they were able to obtain conveyance of the plot comprising the house, stables, croft and gardens with permission to carry out any necessary repairs for the accommodation of the headmaster.

On 31 August 1911 the governors sold Westbrook House and 7 acres of land to a silk merchant, Richard Brown of Ellesmere, Buxton Road, Macclesfield. In September 1933 it was sold to a solicitor's clerk who, after almost seven months, sold it to Macclesfield Corporation. With this purchase the park was then enlarged to approximately the size it is today.

Orme's Croft and Parkland

The 4 acres of land lying immediately through the Cumberland Street entrance had been in private ownership before their incorporation into the Westbrook Estate. The portion relating to the Cholmondeley original parkland had been sold off during the great sale of 1788, but it had been let in closes. One of the lessees, John Orme purchased just over one acre of the Longlands from Lord Cholmondeley on 7 March 1799 which enlarged his original Orme's Croft, previously mentioned (see *Past Times of Macclesfield vol. 2*, p.276) and part of what is today Whalley Hayes car park. Exactly the same situation applied to an adjoining croft bought by Thomas Mather.

The remaining small closes, together with the latter two, passed through several ownerships and were the subjects of small loans or investments at a crucial period in English history, i.e. the Napoleonic Wars. They were all eventually brought together into the Westbrook Estate by Revd Yates, who at that time was the mortgagee, but with the 'power of sale'.

Westbrook House was demolished many years ago, but what remains of the stable block give an idea of the original style of architecture. The stables, which still retain features indicating the accommodation for coach and horses, are now the park offices; the kitchen garden is occupied by greenhouses and the site of the house (which resembles a large car park) utilised for equipment etc. Today almost 16 acres are open to public access.

South Park

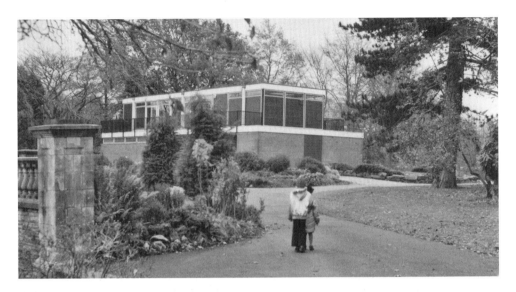

The present pavilion and tea room not far from the site of where John Ryle's Park House once stood.

The opening of West Park in October 1854 had been followed by Victoria Park some forty years later. However West Park was located in the north-western part of the town, and Victoria Park to the south-east. But another area, which had rapidly developed following the Napoleonic Wars, was around Park Street and lower Park Lane in the south-west of the town, and it was near this area where the next park would be situated.

The whole of the South Park area today had originally been part of the medieval parkland of the kings of England; this had eventually passed to the Chomondeley family by the eighteenth century. The subsequent sale of 1788 had seen the extensive parkland auctioned off in lots and some were bought by John Ryle Snr.

Ryle House Estate

The Ryle estate has already been included in previous articles, but a brief mention is necessary to tell the story of South Park.

John Ryle Snr had made a fortune in the silk trade and in 1788, when he purchased several large plots of land from the Cholmondeley estate, he was already lessee of a large area of land from Waters Green to Parsonage (Park) Green from the Pickford family. His house was comparatively modest and is still standing with its entrance on Sunderland Street (formerly a doctor's surgery, now a funeral director's premises), but with a side view overlooking the Memorial Park on Park Green.

With the addition of the Cholmondeley parkland, Ryle created the Park House estate and built an impressive house on the site of where the present South Park pavilion and tea room stand. The

carriageway led diagonally north-eastwards to exit somewhere on the site of the present Harvest Printers' building between High Street and James Street.

Park House had 'large grounds with extensive walls and gardens'. The pool was referred to as the 'Lake or fish pond' with the alternative names of Ryles Pool or Park House Pool.

John Ryle further consolidated his holdings by purchasing the plots he leased in the Sunderland Street area so, apart from the small green (now the Memorial Park) that had been allocated to the Corporation under the Enclosure Act of 1804, his lands stretched from almost the present railway station to Park Green, and then along the southern side of Park Lane and part of the northern side to what is now Congleton Road. The southern boundary is today represented by Moss Lane, but the eastern boundary is not so well defined, except that part nearest to Park Green which abutted Mill Lane. This was a considerable estate which included three farms.

After his marriage John Ryle Jnr lived in Park House, where his children were born, and he inherited the estate together with silk factories in Macclesfield town after his father's death on 16 June 1808. In 1837 he bought an estate at Henbury where the family moved shortly afterwards, but by 1842 Ryle Jnr, having invested heavily in the cotton trade and a banking concern, was declared bankrupt, and his lands were auctioned off. What happened to Park House is at present unknown, but it appears to have been periodically sold and then leased. However, some of the surrounding land of approximately 52 acres including the pool, was left with the house to create a more compact Park House estate.

By the end of the century this smaller estate was owned and occupied by a Harriette Clarke. She died on 7 February 1906 leaving the house and its little more than 52 acres to be disposed of by her executors. On the west it reached what is now Ryles Park Road, but did not include Ryles Farm (the house is still standing). Apart from the farmhouse none of the present-day properties on Ryles Park Road had been built. The south and eastern boundaries were almost the same as those of South Park today.

Plans

The executors, Edward A. Clarke and Edwin K. Hilton seized the opportunity to invest heavily in part of the Park House estate by way of mortgage and an elaborate plan was submitted to build a large housing estate. Park House itself and the remaining land seems to have been sold off in lots. Roads were to be laid out, one from the upper end of Hobson Street almost on a line with today's path (by the small mill with chimney) and called Sutton Road. Poplar Road was continued through the park to join it – the remnants still remain today as a double pathway.

The present path, from the extension of Poplar Road to the small car park and Park Grove, is now parallel to what was laid out and named Park Avenue, but it was nearer the present nursery school and would have passed between the two large lime or linden trees to the right of the path. The plan shows the whole of that area from Hobson Street to Park Grove covered by houses. However, it was too ambitious and on 13 October 1911 Josiah Smale of Lyme Green, (Sutton silk manufacturer) took on the proposed estate by mortgage, together with Park House, the pool and a very large acreage of surrounding land.

It appears that by this time the executors had sold off smaller plots on the periphery of what is now South Park.

The Smale Estate

In 1911, having purchased a significant area of what is today South Park, which included Park House and most of its surrounding land with 'Ryles Pool', the silk manufacturer Josiah Smale, like the previous owners Clarke and Hilton, appears to have had some problems, so the plan for the large housing estate was delayed. On 21 June 1912 he sold a 3 acre part of the land to the Macclesfield Equitable Provident Society Ltd. The area was used commercially and had its own pool known as Hobson's Pool, which was eventually drained. Today it is part of South Park and used as a football field adjacent to Hobson Street.

Josiah Smale died and his widow Elsie Beatrice of 'The Hut' in Sutton, sold the larger part of the area for the proposed housing estate to William Frost on 15 August 1918. He had been mayor of the town in 1910, and was an important alderman and silk manufacturer.

Almost immediately in September 1918, the Provident Society, no doubt with great persuasion from Alderman Frost, sold their plot to him.

Alderman W. Frost

Now that William Frost had possession of the whole of the intended housing development area, he seemed determined that the plan should not go ahead. He had decided on another ambitious scheme, which he must have considered would benefit the area and the people in that part of town. His idea was for a recreation park, which no doubt he enthused about to other Corporation members; in fact it is known that the male members of the Frost family were keen on crown green bowling, and that two of the brothers and their families lived in close proximity to the envisaged amenities.

Being a public spirited and very generous man, Frost made the substantial offer of the land to the Macclesfield Corporation, together with certain proposals. These proposals were accepted, which included the closing of Sutton Road and Park Avenue together with the extension of Poplar Road, he then gave the land to the Corporation on 8 April 1919. However, still not satisfied he set about enlarging the area for his vision of another excellent park.

The larger part of the estate, comprising Park House and some surrounding land together with Ryles Pool, had been bought by Harry and Emma Birtles sometime earlier. This Alderman Frost purchased on 8 July 1921. He also set about trying to acquire the other smaller plots of land on the periphery in private ownership.

Building had started along Ryles Park Road, which had reduced the acreage a little, but he was able to purchase from William Fawkner of Ryles Park part of a plot that Elsie Smale had sold on the north-western corner of the estate. This was bought to widen that part of the road known today as Park Vale, but which was originally part of Grange Road. In fact the present-day Grange Road continued westwards straight through the park and ran along the side of where the tennis courts are now situated.

Frost also purchased one or two smaller plots in the present Grange Road and Hobson Street areas. He must have been disappointed, however, that he could not retrieve that portion of land along Park Lane now opposite the Twelve Apostles (i.e. from the part of Park Vale Road that leads to the main entrance of the park and stretches along Park Lane eastwards to Park Grove).

A member of the Frost family had actually paid for the building of one of the Apostles houses and had taken up residence in the house some years earlier.

The present size of South Park is reckoned to be a little over 45 acres, making it more than twice the size of West Park. This is a large area and Alderman Frost realised the necessity of having access, not only from the Park Lane and Hobson Street directions (i.e. from the north and east) but also on the southern side.

The land to the south and south east was owned by two other silk manufacturers, Edwin Crew (where St Edward's Junior School now stands) and William Whiston (in the present Maple Avenue and Byron Street area). Frost's negotiations were successful and he gained a small portion of land from each. This allowed people access through the upper end of the park to and from, what is today, Maple Avenue and the Western Avenue areas.

The final conveyance of this large area of land was made to the Corporation on 31 March 1922 with the stipulations that it was to be known as South Park, used as a public park, open space or recreation ground, including features for ball games. It was also for the benefit and enjoyment of the people, and to ensure that his gift was kept as he intended, trustees were appointed. This was an extremely generous gift and Frost's intentions must never been forgotten. He lived in an era when parks were respected and greatly appreciated by all sections of the public.

The Macclesfield Psalter

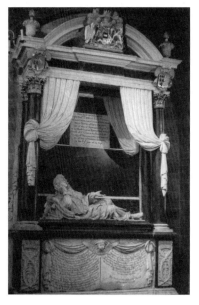

The magnificent Earl Rivers monument by Stanton in St Michael & All Angels Parish Church, Macclesfield.

For a few months in 2005 there had been much media coverage about a medieval manuscript named 'The Macclesfield Psalter'. It is an intriguing story and one which leaves many questions unanswered. The reason for the name is, however, easily solved and quite straightforward.

The psalter was found in a rare and extensive collection of manuscripts and library books (totalling around 12,000) in Shirburn Castle, Oxfordshire. From 1716 to 1922 the castle was owned and occupied by the earls of Macclesfield; a family with the name of Parker.

In 1922, in order to avoid death duties George, then the earl, set up a trust that operates under the name of Beechwood Estates. The present directors/trustees are the earl, his brother, his uncle, a nephew and two cousins.

Feuding between family members began some twenty years before. The earl, who paid a rent to the estate, claimed the right to live there for the remainder of his life. This was contested in the high court and his co-trustees, who claimed that the maintenance of the castle has not been carried out according to the conditions of the earl's tenure, won their case.

Faced with eviction, yet rightful owner of many of the castle's contents, the 9th Earl, Richard Timothy George Mansfield Parker decided to auction off many of the family treasures. His reason was that he had bought a smaller property to move into. It was Sotherby's Auctioneers, when called in to prepare the inventory, who discovered the psalter.

The Macclesfield earldom does seem to have created some interesting stories from time to time. The first appears in 1688. The Corporation rights on Macclesfield Common had lapsed during the chaos of the Commonwealth period, and after the Restoration, with monarchs desperate for money, both Charles II and James II had leased out the encroachments to individuals. Surprisingly Lord Gerard, Earl of Macclesfield, had been 'recently outlawed' which resulted in his privileges being forfeited. The Corporation took action and won their claim that he had illegally acquired the tenure. Who this character was is at present unknown, however in 1697 wanting to divorce his wife, Ann, the 'Earl of Macclesfield Case' was brought before the House of Lords (divorces were then by Act of Parliament).

Ann was accused of having an illegitimate son after an affair with Richard, Earl Rivers, son of Thomas, the 3rd Earl, whose magnificent memorial is in St Michael's Parish Church in Macclesfield's marketplace. The child was looked after by a London shoemaker, but supposedly died and the shoemaker presented his own son, Richard Savage, as the illegitimate child.

On his deathbed Earl Rivers, wishing to leave the boy an inheritance, asked of his whereabouts, but was told of the death by the Countess. Richard Savage grew up insisting that he had been deprived of a fortune by his wicked mother. One person who believed him was Dr Johnson, although lack of evidence to substantiate the claim does suggest, as many believed at the time, that it was a ploy by her husband to discredit Lady Macclesfield's character. With the divorce she forfeited her title.

The Parkers

The second creation of the earldom related to the Parker family. The Parkers had an estate in Leek. Their house was next to St Edward's Church in the Market Place and is now divided into small shops. Thomas Parker, born there in 1666 was educated in Shropshire, became a lawyer and was admitted to the Inner Temple in 1684. His rise in society was rapid; he became Whig MP for Derby in 1704, was knighted the following year, and gained the position of Lord Chief Justice for England in 1710. He became a favourite of George I, who ascended the throne in 1714 and created Thomas Baron Parker of Macclesfield in the same year.

Two years later Thomas chose Shirburn Castle as his home, a suitable abode to go with his additional titles of viscount parker of Ewelne and Earl of Macclesfield in 1721. In 1725, and in disgrace, he was tried for financial irregularities and corruption, which he vehemently denied. Found guilty he was struck off the roll of the Privy Council and fined £30,000. After release from the Tower of London, where he had been held pending payment of the fine, he withdrew from public life and returned to Shirburn Castle. He only lived another seven years and was succeeded by his son George in 1732. Succeeding earls did much to restore the family reputation, but it was probably Thomas who had acquired the most superb collection, having held far higher public office than any other family member.

Although several books in the collection have proved to be extremely valuable (e.g. a 1543 first edition by the famous astronomer Copernicus), yet the Macclesfield Psalter is the most precious. Thanks to many donations it is now housed in the Fitzwilliam Museum in Cambridge.

A psalter was a medieval prayer book containing Old Testament psalms. Many were beautifully illustrated, but few have survived, particularly those from Gorleston in East Anglia where the Macclesfield example is believed to have been produced in 1320. Some of its illustrations are so ribald in character, verging on the obscene, that it is both amusing and surprising to see them so exquisitely and artistically executed in such a devotional book. It begs the question, 'which character commissioned the psalter and which artists complemented the interpretations of the text in this unique way?'

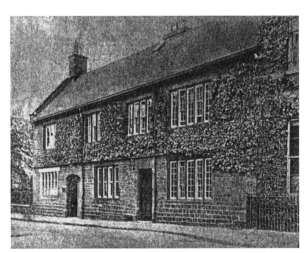

Home of the Parker family in Leek, Staffordshire.

Eccles House

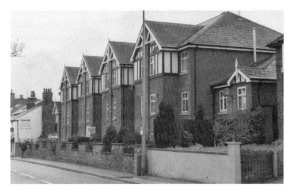

The group of houses on Upper Park Lane built in what was the front garden of Eccles House.

Eccles House before demolition.

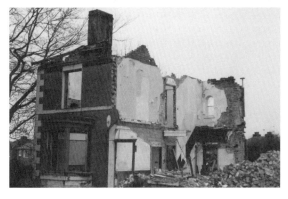

Eccles House during demolition revealing some interior details.

Once a leafy lane with few ancient buildings along its verges, Park Lane today is one of Macclesfield's busiest thoroughfares. Development began in earnest after the Napoleonic Wars and, while some of the properties from that period still remain, more modern buildings have subsequently filled vacant spaces, though very rarely by demolition of an existing property.

The great exception is the latest group of houses built opposite Macclesfield College, on upper Park Lane. In the late 1980s the site was occupied by a large house that stood back from the road and was surrounded by a good-sized garden.

The site had been derelict for quite some time, yet the house was intriguing. As the property had been put up for sale and demolition seemed imminent, it was essential to quickly take a photo. Unfortunately I arrived too late and discovered a large pile of bricks with only a third of the house still standing.

After the site had been cleared a new row of dwellings was built. These now lie close to the road, obscuring any sign of the former garden: however, thanks to another enthusiast of Macclesfield history who succeeded in buying some old documents at an antiques fair, some interesting information came to light about the original house.

The story begins in Eccles, West Lancashire, where a weaver called Thomas Bradburn and his wife Mary baptised their son Samuel on 5 May 1826, during the reign of George IV. The King was succeeded by his brother as William IV in 1830, but, shortly after Samuel's eleventh birthday, Queen Victoria became the reigning monarch in June 1837.

Corn Merchant

How Samuel came to Macclesfield is unknown, but circumstantial evidence seems to support the assumption that his father, being a weaver, obtained employment in a Macclesfield mill and brought his family with him.

Samuel's will, proved on 20 February 1884, states that his wife was Harriett and he had six surviving children, two sons and four daughters. He had died the previous year, and an inventory of items belonging to his estate in November 1883 makes interesting reading.

Samuel had evidently become quite successful as a corn merchant. He had an office at No. 8 Brunswick Street, a warehouse in King Edward Street and the fine house on Park lane which he called Eccles House, evidently after the place of his birth.

The warehouse contained a high-wheel truck, an iron weighing machine and a wheel and axle hoist. The office building comprised six rooms. On the ground floor there were three, one of which was the office. It contained an iron safe; a mahogany office desk and a painted oak desk; three chairs, one described as a 'Rushseated high Chair'; a clock and several items relating to stationery.

The other two rooms were divided by a glazed partition and related to the business; there a weighing machine 'sixteen dead weights', two sack trucks and old stools are recorded.

The two first-floor rooms were used for storage. The front room had a hoist with chain and brake and also an Avery weighing machine etc. The 'Back Room' contained two sieves, an oilcake crushing machine, a grain shovel and weights. Oilcake is a compressed mass of oil seeds such (as rapeseed or poppy seeds etc.) and, after as much oil as possible has been extracted, it is used as food for fattening sheep and cattle.

Finally, the second-floor room, known as the 'Top Room' contained a beam and scales, several hooks, two step ladders and a horse saddle.

The House

Eccles House had some interesting items and sets the Victorian scene well with displays of wax flowers under glass dome-shaped covers, oil paintings entitled *Cutting Timber, Lake and Monastry* [sic.] and *Lake and Windmill in Moonlight* etc. china and items of needlework.

The drawing room sported a Brussels carpet, a fine Burley & Burley walnut piano, a walnut and birch what not, a mahogany music cupboard and an inlaid walnut table. There was also a walnut spring-seated couch, six mahogany chairs and other expensive items of furniture. The walnut couch covered with tapestry had been purchased on 15 May 1883 from Arighi & Bianchi for the sum of £4 10s.

The sitting room was similarly furnished but seemed to be more of a games and reading room with card tables and bookcases. Apart from cutlery and crockery the kitchen had a dresser, tables and chairs, two canaries in separate cages, a sewing machine and various small brass items such as a compass and candlesticks. The scullery had the ubiquitous dolly tub, wringer, wash tub and metal items such as pans, tea pots, and shovels among other items. The pantry contained further pieces of crockery and containers for food.

Three of the four bedrooms had Tudor beds with expensive bed hangings complete with fringes, one of crimson damask. There were straw mattresses and flock beds with blankets and coloured counterpanes. Most of the furniture was again walnut or mahogany, which today would make it an antique dealer's paradise.

The eldest son died shortly after his father, closely followed by his mother. The other son, who lived on Barton Street seems to have died a batchelor. Of the four daughters, three married into local families and the other remained a spinster, living in Bollington. What happened to the house and business is at present unknown.

Windmills

The windiest corner in Macclesfield where Castle Street joins Churchill Way, the probable site of a medieval windmill.

The western end of Castle Street, where it joins Churchill Way, has to be the windiest area in Macclesfield, an ideal site for a windmill.

Castle Street is, of course, a relatively modern creation, only laid out during 1922/23. Originally fields and buildings would have occupied the area, and somewhere in the vicinity were the windmill fields. These are referred to in a list of the earl of Derby's leases for the year 1634, when Elizabeth Ridwick and her son Anthony (Antonio) were paying rent for a house, croft and part of the 'Wyndemille fields'.

Several of the other rentals indicate that the earl owned a large area of land stretching across part of today's centre of Macclesfield. It included at least part of Waters Green (possibly from Hurdsfield) and the area of John of Macclesfield's crenellated mansion (hence the name Castle Street). It appears to have continued across Mill Street encompassing part of the land now occupied by Castle Street and also land on its southern side until it reached Barn Street, the latter now being part of Churchill Way.

By a process of elimination the fields referred to fit well into the area now partially occupied by Craven House.

Some 200 years earlier, there is a reference on a deed of 1438 to the existence of two watermills under one roof and a windmill. The watermills have previously been featured in a *Past Times* article and would be those situated on Mill Green in Sutton and known as The King's mills. The windmill, however, is more than likely the one which stood within the then Macclesfield borough and provided the appropriate name for the fields.

But what would this early mill have looked like?

Post Mills

While the two water-powered mills would have been built of stone and therefore quite substantial buildings, the windmill would have been very different. These early types of windmill were called post mills and were timber framed. They had the appearance of looking rather like a huge grandfather clock but with a broader base. The sails rotated around the 'clock face' and assembly was comparatively easy.

Each of the principal joints was numbered, sometimes in Roman numerals, but often ancient runic characters were used. By this simple method the windmill could easily be made in one location, transported and assembled in another. The windmill sails always faced the wind, and one of the miller's daily tasks was to position the mill so that the sails might hopefully caught the full effect of the wind on any particular day. This was an irksome task which also involved repairing the common sails, similar to those on a boat.

The sails were constructed as simple rectangular frames and the miller arranged his canvas on them. The two sail stocks were placed at right angles and fixed through the wind shaft.

Progression

By the mid-seventeenth century these early post mills were being replaced by smock mills. These were also fitted with common sails, but instead of having to turn the whole body of the mill into the wind, a new innovation was made. The top, to which the sails were fitted, could be revolved, saving the manipulation of the whole structure.

It would be another century before John Smeaton introduced cast iron into windmill construction to supplement the use of traditional timbers. A further development in 1772 by millwright Andrew Meikle saw the sails adapted to those with which we are most familiar today (i.e. having a series of shutters which resembled Venetian blinds). From an engraving of Charles Roe's windmill built on Macclesfield Common in 1772, the mill still retained the common sails for some years. By the time of its removal to Kerridge, just before the mid-nineteenth century, it would have been modernised and fitted with the shutter-type sails. Incidentally the sails of Charles Roe's windmill appear to have moved anti-clockwise.

Returning to the windmill in the centre of the town, it is unlikely that this ever progressed beyond being a post mill. In March 1691 the Corporation decided to erect a malt mill, which was built on Dog Lane. The eastern end of Dog Lane was entered from the Market Place and later became Stanley Street, now incorporated into the Indoor Market. As evidence of the existence of the early mill seems lacking after the early seventeenth century, it suggests that this had long since been pulled down, but it would have been an interesting sight on a windy day as the wind swept in from the west across the Cheshire Plain, or blew down from the Pennines on the east.

The King's Oven

By the early seventeenth century the three Macclesfield mills, that is the windmill in the centre of town and the two mills worked by water wheels on what is now Mill Green in Sutton, all had millers by the name of John.

The mills provided for the production of the two most basic essentials at that time, bread and beer. And Macclesfield, being an important market town where livestock fairs were attended by people from considerable distances, grasped the potential for developing these two vital businesses.

According to custom the inhabitants of Macclesfield were obliged to use the King's Oven, or as it had become known by that period, the town bakehouse, for their own bread and pastries and a

An Edwardian view towards Macclesfield Market Place. The Town Bakehouse would have originally stood behind the man on the edge of the pavement; the Guildhall was then much smaller than its columned successor.

reasonable toll was levied. Otherwise they purchased bread from the bakehouse, which stood close by the guildhall but quite separate in case of fire breaking out.

The Flour

Some residents would, of course, have bought their flour from the millers direct or have used hand mills or querns to make their own flour from the grains of wheat purchased from farmers on market days.

Querns were a simple device consisting of two stones, one flat on top of the other. The top stone had a hole in the centre through which the grain was poured and another near the edge into which a stick was pushed to act as a handle. Sometimes the upper one was two-handled (known as a saddle quern), but whichever device was used the method was the same; the upper stone revolved or was moved backwards and forwards against the lower one, thus crushing the grain trapped in between.

This would be followed by a primitive refining with a sieve to collect the better quality for bread baking.

The town baker would store his sacks of flour from the mills in cellars or lower rooms, otherwise, especially in summer, black winged insects called nightingale maggots hatched out and ate it. It was also advisable to store the flour in large covered bins rather than keep it in sacks to prevent contamination by vermin.

The Oven

The oven was constructed from the thickest sort of brick with a low roof and narrow mouth. The whole of the outside was plastered and the bottom or hearth was often made from loamy soil, much preferred to 'Fire-stone or Brick Tyle'. At each relighting of the fire, the oven was gradually heated to prevent any damage to the structure, and when hot, care was taken to remove any ashes so that the coals or wood could burn well.

Flour from new corn was preferred, but it had to be ground 'quick and speedily'. This meant that the mills would have to be kept in good repair, because millstones that were worn did not perform well.

The best bread was made wholly from wheat flour, the poorer contained one fifth barley. Having mixed the leaven, flour and warm water together about 10 o'clock at night, the dough was left overnight and kneaded well the next morning until stiff. It was then placed in a trough and the baker thrust his fist into the dough 'to the very bottom of the trough in two or three places'. It was then covered with meal sacks and clean blankets.

The dough was left standing for a while, longer in winter than summer, and when the holes had closed up with the swelling, the mass was cut into pieces weighing 16 lbs each (a little more than 7 kilos); meanwhile the oven was hotting up.

Each piece of dough was then taken and formed into loaves that were left on a clean tablecloth. The oven was wiped clean with a 'map wet' (wet mop), closed up for a short time to allay the heat and dust, and then filled with the loaves as quickly as possible. The larger ones were put at the upper end and the middle was filled last.

It was now important to use an iron (a sort of rake) to keep the fire hot and even below the oven. The mouth of the oven was covered with a plate door and the edges of it with wet cloths to keep in the heat.

It took approximately four hours to bake a large loaf, and when removed from the oven, the bread was allowed to cool before being placed in bins in the cellar.

Recipes

All sorts of recipes were available, published in small booklets which were sold by chapmen at the fairs or during the meanderings around the countryside, and one even suggested that stale bread would 'recover' by placing it into the oven and eating it immediately.

A Macclesfield favourite was gingerbread, and one can well imagine the appetising smell from the bakehouse filling the Market Place on market days. For baking white bread or gingerbread one penny was charged for every twenty pennyworth. For every measure of corn made into brown bread, or every score of mince pies or tarts a charge of four pence was made, and for every

four other pies or custards, one penny. The giblet pies were the most expensive costing one penny each to bake. This of course related to the old monetary system when 240d equalled £1.

From this medieval beginning Macclesfield would eventually produce its famous Hovis bread.

Having begun with the medieval mills of Macclesfield, the story is ending with the last of the windmills in town.

Mysterious Mill

Most people, like myself, would assume this to be Charles Roe's windmill on Macclesfield Common, which had initially ground up the calamine for brass production but was subsequently converted to a corn mill.

However, an astute reader from Reading (a former Macclesfield resident) has surprisingly discovered another. As he rightly points out, on a map of 1831 there is a symbol for a windmill in the area bordered by what seems to be Newton Street, Paradise Street, Henderson Street and Bridge Street. It does not appear on a later map of 1838, which suggests that it existed mostly during the significant yet short reign of Queen Victoria's uncle, William IV (1830–38).

When walking down Newton Street and turning the corner left into Paradise Street in order to walk down to Bond Street there is nearly always a strong breeze blowing up that section of the street. It is easy to imagine that before the houses were built between Bond Street and Oxford Road, the effect of the south-westerlies would have been even more pronounced.

Although difficult to judge from the 1831 map exactly where the windmill would have been sited, it appears to be more at the top of the steep little hill adjacent to the area of what is now the intersection between Paradise Street and Newton Street. Unfortunately the problem with windmills as buildings is that they rarely seem to be specifically mentioned in property deeds of earlier periods, only the land on which they stood.

There is also the intriguing question of why a somewhat spacious area of slightly raised rough ground, now part of Back Paradise Street, should exist in an otherwise intensely built-up part of the town, next to Granelli's ice cream premises. The idea of someone building a windmill there does not therefore seem to be an altogether unusual idea.

The site of Granelli's premises, previously a Victorian bowling green for the Brewers Arms, but earlier the indications are that a windmill had existed between the buildings on the left on what is now Back Paradise Street and the present day site of Granelli's.

The Evidence

The windmill also appears on the well-known print of that period showing a view of the town from Buxton Road. It is on the extreme left of the picture, and has historically been automatically assumed as the Roe windmill on the common, but this now seems incorrect. The perspective is distorted, because it is too near the tower of Christ Church.

The question of why a windmill would be built there is an interesting one. This area of Macclesfield began to develop after the Napoleonic Wars. It had once been part of the great parkland of Macclesfield Manor belonging to the sovereign of England, but had been sold off in lots during the late 1780s by Lord Cholmondeley the then owner, and for some time had been kept as agricultural land.

However, with a population explosion from the 1790s onwards, due to better health care, the town needed more land for building purposes. By 1825 the population had almost doubled, and William Roe (son of Charles) had already begun the development of the area around Christ Church, inspiring others to follow.

The 1831 map shows that the terraced houses on the eastern side of Bond Street had been built up to Crossall Street This, of course, included the row with the Crown Inn near to Paradise Street, and having delved once more into 'The Pubs & Breweries of Macclesfield' booklet the following information is worth considering.

The Crown was not only a public house but also a brewery with what seemed to be great potential. It had stables and a brewhouse with a pump to provide the necessary water, all occupying what originally must have been the corner site of Bond Street and Paradise Street. By 1847, when the pub was put up for auction, the brewing business was gone and the buildings had been converted into five dwelling houses, two on the lower side and three that were three stories high on the upper side to the corner. These houses were all tenanted.

Could the windmill have been part of the original brewery plan? It does seem likely, however, with the building of the houses on Bond Street the full effect of the wind for operating the mill sails would no longer be guaranteed.

Certainly the whole project had a very short life, but as if inspired by the former, two breweries were established in the area some years later. The first was the Bond Street brewery built in 1862, shortly followed by Thackray's Bridge Street brewery in 1865. The former, then under Marston's ownership, as many will remember, closed finally in 1989, but the latter had been demolished more than 100 years earlier in 1883.

Arighi Bianchi

The story of Arighi Bianchi's distinctive façade surprisingly begins over the Cheshire border in Derbyshire. Many of us are familiar with the story of William, 5th Duke of Devonshire; his vibrant and charming wife Georgiana; their affairs, and particularly the ménage à trois which included Georgiana's good friend Lady Elizabeth Foster.

Surprisingly their only son and heir, William Spencer Cavendish (1790–1858) never married. On the death of his father he became the 6th Duke at the age of twenty-one years. He was known as the 'Bachelor Duke' and his acquaintances referred to him as the eccentric Duke of Devonshire.

He lavishly entertained his friends, spent a fortune on his many properties and various collections. Not long after the Napoleonic Wars the 6th Duke, who owned land adjoining the Horticultural Society's gardens at Chiswick in London, met one of the Society's young gardeners and was extremely impressed with his work.

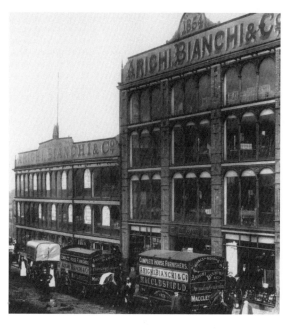

A unique photograph of the newly opened premises of Arighi Bianchi on Commercial Road, Macclesfield, in 1892 courtesy of Paul Bianchi.,

Joseph Paxton

In 1826 the young man, Joseph Paxton, was given the position of head gardener at Chatsworth House, the Duke's ancestral home in Derbyshire. Together they transformed the gardens into those most visitors see today.

The Emperor Fountain still remains and can reach a height of at least 280 feet, on a calm day, but one notable feature is missing, Paxton's Great Conservatory. It was a phenomenal achievement constructed in wood, iron and glass, and when completed covered three-quarters of an acre. The inspiration for this is said to have been two remarkably different sources, a lily and Ecton copper mine.

It had been the Duke's father and grandfather who had reaped a vast fortune from their mine just over the Staffordshire border near Hartington village. And this was the mine from which Charles Roe had purchased considerable amounts of copper ore for his smelters on Macclesfield Common during the decade beginning in 1761. Part of the Devonshire profits were used to build the Crescent at Buxton.

Where descriptions of the ores are found, the beauty of their colours and forms certainly impressed. Apart from the rich yellow copper ores, they sometimes occurred in purple, brown or steel blue together with a translucent calcite occasionally of a beautiful yellow and a colourless ore bluish fluorspar. The latter was said to have impressed Paxton so much that he chose to create

a building using as much glass as possible- a considerable task. However, his greatest claim to fame began in 1850.

Prince Albert, Queen Victoria's consort, envisaged a great international exhibition from which 'nothing great, or beautiful, or useful' was to be excluded. All sorts of problems arose when it was realised that a building would have to be specially built. The Exhibition Committee rejected 233 designs, chaos reigned but the 'eccentric Duke of Devonshire' stepped in and. with great encouragement from Prince Albert, Paxton put forward a design which was accepted.

His structure was based on his Great Conservatory and 'his' lily. Paxton had also built a very small conservatory at Chatsworth to cover a single plant. It was a South American giant lily named Victoria Regia, which under Paton's paternal care had actually flowered. The structure of the lily together with the wonderful crystal effect of the Ecton mine were used as the inspiration for his masterpiece 'The Crystal Palace'.

It contained 900,000 square feet of glass, was supported by 33,000 iron columns and 2,224 girders. The Great Exhibition was opened by Queen Victoria on 10 June 1851 in Hyde Park. A few months later, after much wrangling about its future it was removed to Norwood where two fountains were created in the gardens. These were described as 'the world's most stupendous fountains', but only equalled the one already created at Chatsworth.

The Company

Just three years later there arrived in Macclesfield Antonio Arighi from the village of Casnate on the southern shores of Lake Como in Northern Italy. He started a clock and barometer business on Waters Green selling to farmers and their neighbours in the surrounding countryside. Soon the business grew, and he was joined by his son-in-law and cabinetmaker, Antonio Bianchi, also from Casnate. The business became a great success resulting in a partnership between the two and a desire for larger premises.

In 1883, trading as Arighi Bianchi they moved into the old silk mill on Commercial Road, supplying a complete furnishing service for the family home. They were especially renowned for their fabrics such as tapestries, damasks, laces and velvets, imported from all over Europe.

Soon a local builder, George Roylance created a remarkable four-storey building next to the mill, which opened for business in 1892. The design was based on that of Paxton's Crystal Palace, and a new comparable façade was given to the renovated silk mill.

The Second World War badly affected business, so the silk mill was leased and eventually sold to W. K. Lowe Knitwear Ltd, with part of it used during the war for parachute production. Finally, after much deterioration, the building was demolished.

Arighi Bianchi & Co. (a limited company from 1900 when nephew Francis Arighi joined the partnership from Italy) has survived many difficulties, including threat of demolition to accommodate what is now the Silk Road. But a Grade II listing for the unique building with its iconic façade saved the day and the old silk mill land was bought back to facilitate parking.

With a younger generation once again taking its turn at the helm, the company is looking forward with confidence to a successful twenty-first century.

Naval History

In October 2005 the nation was celebrating the bicentenary of one of Britain's greatest naval victories - Trafalgar, on 21 October. As an island nation we are never far from the sea, and in inland towns like Macclesfield with strong army and air force traditions it is easy to overlook the incredible role that the navy has played throughout our history.

At the end of the eighteenth century, with the development of lower Park Lane, Macclesfield remembered when victories in the West Indies provided the names for Nelson, Rodney and Vincent streets. Perhaps having already named Nelson Street before Lord Nelson's greatest achievement in defeating both the French and Spanish fleets off Cape Trafalgar on the southern coast of Spain in 1805, the street is not as prominent as expected.

However, within the last couple of years, due to the improvement of lower Vincent Street with the building of new apartments, we now have Trafalgar Square adjacent to Churchill Way.

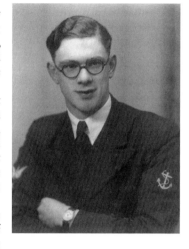

Petty Officer James Howard Smith.

Continuing the naval theme the opportunity arose to highlight a much forgotten part of naval history from the Second World War – the role of minesweepers. In 1986 Commander Hilbert Hardy wrote that the success of minesweeping was a 'long and tedious struggle rather than a series of vivid battles'. Because of the secrecy involved it was the 'silent service of the Royal Navy' and with the overwhelming rejoicing at the end of the war and a desire to 'get on with life', the heroics of both

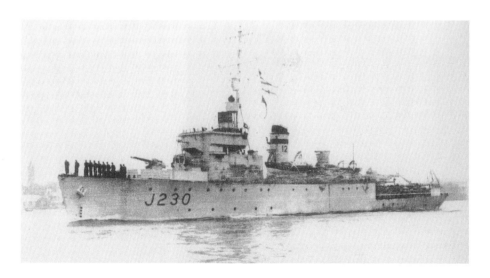

HMS Cadmus, a minesweeper of the 'Algerine' Class. Reproduced by kind permission of the Naval History website.

the merchant seamen and minesweeping crews, which out of necessity had been kept out of the headlines, were soon sidelined and forgotten. Here, however, is the story of one such crew member.

Born in North Lancashire, James Howard Smith, known to all his friends and colleagues as 'Jim' (he retired as a senior financial officer of Macclesfield Borough council in the early 1980s) had proudly gained the reputation of being 'a true Maxonian'. Articled to a firm of accountants at the age of sixteen, he joined the Royal Navy at Alsager in Cheshire (not too far from Macclesfield) just after his eighteenth birthday in January 1944, and as he remarked, 'You carn't get much further from the sea than Alsager!'.

By that time in the war recruitment was either as a 'Bevan Boy', which meant working in the collieries, or the navy. As James lightheartedly remarked, 'I was fortunate to have a Mediterranean cruise paid for by the government'.

He was judged psychologically suited to submarines, but after sitting an exam was sent to Rutherford College, Newcastle-upon-Tyne, to study radar. The course was extremely difficult, radar was in its infancy, and apart from one other colleague the rest were PhDs. Many failed, but James passed and was sent to join the 12th Flotilla of Algerine Class fleet sweepers off the Mediterranean coast of Italy. By the age of nineteen he was acting chief petty officer radar mechanic in charge of all radar equipment for a flotilla of eight ships.

The flotilla was led by *Acute*; his ship was *Cadmus* which, by a strange quirk of fate, together with the other Algerines *Circe*, *Espiegle*, *Mutine*, *Fly* and *Albacore* drew the comment from one writer that they 'raised memories of the days of Nelson in the Mediterranean'.

Minesweepers were always the first vessels into any sea battle zone. They often worked under heavy shore bombardment and air attacks during hours of darkness. The assault on Anzio saw the *Cadmus* attacked by both shore guns and ten aircraft (Me 109s), fortunately the bombs missed her.

This was the war zone in which James, as a raw recruit, found himself serving. Most crew members were hardened sailors of many years. One day, sitting on deck, he stitched together a cover from strong canvas for his tool box and was spotted by an old hand, from then on he was accepted as a full crew member.

He served almost three years to November 1946. At the end of the war there was still much mine clearing to do, and their flotilla was the only one paid by the Italian Government to sweep the channel from Genoa to Naples. The flotilla was based at Leghorn.

The highlights were concerts for the troops by the famous Italian tenor Beniamino Gigli at his villa near Naples, and James's job of 'thumbing lifts' in whatever naval vessel he could find to collect post from Elba and Naples. He was fortunate to see the gleaming Italian battleship *The Duke of Aosta* built of aluminium due to wartime restrictions.

The lows (only mentioned twice during our thirty years of marriage): late in 1944 the flotilla was scrambled north during the assault on the River Scheldt. The radar broke down and with absolutely nothing with which to repair it, and a captain shouting in his ears, his attitude to life suddenly changed – it was no use worrying. As Hardy points out they fought an enemy they could not see with tools they did not have – one of the ships was lost.

They put ashore on the Frisian Islands and drank with the locals that night. The next morning James was found badly beaten in an alley, his friend was on the beach drowned!

His only comment was 'I thought they were our friends'. It is now known that German spies were operating in the area,

Returning to Italy the ship rammed the harbour wall of Genoa due to a captain's error, and suffered damage above the water line. The remaining months of the war saw everything battened down, but moisture accumulated below decks resulting in damp bunks. At the end of the war, when the crew returned to Chatham Barracks, half of them were immediately sent to a sanatorium with tuberculosis.

In Churchill's victory speech of 13 May 1945 he said 'we will not forget the devotion of our merchant seamen and our minesweepers out every night'. At last on 14 May 2000 a memorial of marble and granite was unveiled in Portsmouth. It is in memory of all who served on the Algerine Class of fleet minesweepers, including fifteen Royal Canadian escorts.

James would be proud to know that the *Cadmus* takes its place in the list of 114 ships; he died in 1997.

Beer and Ales

History

Beer and ale were originally virtually the same drink. Surprisingly beer was produced some 5,000 years ago in Mesopotamia (Iraq) and gained great popularity in Egypt about the same time. It appears to have evolved from malted bread being soaked in hot water and the liquid drained off and drunk. This 'Beer-bread' links baking with beer brewing.

The Romans were never interested in beer, and it seems to have come to England via Northern Europe, probably with the Anglo-Saxons. In later centuries monasteries were built with adjoining brewhouses to cater for travellers and guests. By 1150 English ale had acquired an excellent reputation, in particular that of Ely and Canterbury, in fact Thomas Becket, as ambassador to the French Court in 1157, took a gift of casks of ale.

Until 1200 ale was regarded as food and not taxed; however, in 1188 Henry II had imposed a national tax to finance the Crusades, and the brewers paid on their stock-in-trade.

Henry III, in 1267, began in earnest to regulate both bread and beer, but it was not until the creation of a Guild in 1493 that beer and ale became two distinct drinks.

Up to this time barley was the main ingredient for the malting, occasionally supplemented with wheat, then, with the Dutch influence spreading through southeast England, gradually hops were introduced.

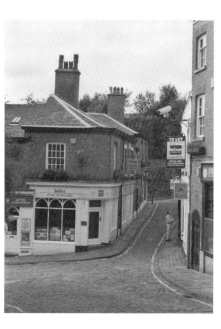

Looking down Church Street towards the site of the original town well used by the innkeepers, among others, for centuries until 1736.

Water was extremely important and it was essential that good clean sparkling water was used, not only for the taste of the ale, but also for thoroughly washing out the brewing vessels and casks. Regulations were strict, particularly with regard to using polluted water from ponds and rivers, hence the success of Macclesfield's beer brewers due to the town's good wells which provided soft water. Hard water could not be used to make good beer, it spoilt the taste and often turned the beer sour in a week's time.

Ale Wives

The Portmoot (Borough Court) records for Macclesfield include the names of those sworn in as 'Custodians of Ale', and show they did carry out their duties, as evidenced by entries for 1376. Beer brewing was done by women known as ale wives, and in that year seven of them were fined 6d each having 'broke the Assize of ale', but exactly what their misdemeanours were is unfortunately not specified. Almost certainly three of these were the wives of burgesses with alehouses around the Wallgate area to the south of the Market Place, and therefore close to the town well.

A few years later, as mentioned in John de Macclesfield's property deeds, he leased from the lord of the manor two taverns on the south side of the Market Place in what are now the cellars of Cottrill's and The Chicken Spit. These would be subleased to others at a profit. Taverns not only sold liquors but also beer and ale.

John also acquired property next to a garden where there was a kiln; this garden was close by or on Jordangate, probably somewhere behind where the present Bull's Head Hotel now stands; and the kiln was a likely candidate for a malt kiln.

There are no descriptions of medieval malt kilns, but the method of malting varied little. Barley was soaked for three or four days in big containers, the water was then drained off and, with the use of large frames, the grains were spread out evenly on the floor of the kiln and allowed to part germinate. This provided the taste for the beer. The barley was then dried by a fire set in the kiln, which at this period by law had to be fuelled with wood, again adding a flavour to the eventual brew. However, peat or straw were used in many places, and with the abundance of peat on the Moss it is more than likely that this was the choice of fuel for Macclesfield ales.

Another advantage for John's tenants and ale wives was the close proximity of the town's well (just down the hill in Wallgate) providing excellent water. This well has always been depicted as a traditional round well with a bucket and winding gear to allow the bucket to be lowered down to the water, and then hoisted up full. But from the position of the fast-flowing stream beneath the present road, it was probably an open well with the water falling into a semi-circular basin-shaped hollow and then running off down the hillside to Waters Green. It is then easier to understand why centuries later (19 August 1736) the Corporation had a good excuse for having the well 'stopt up' because innkeepers were 'apprehended to be a nuisance & to prejudice the health & constitutions of the inhabitants of the Borough'. Presumably they were still washing out their vessels etc. in the open pool; in fact, years earlier a ban had been placed on people washing clothes in the town's well.

Malting

In John of Macclesfield's deeds there is also mention of the 'Wynmulne flat' in the fields of Macclesfield. As the fields extended into lower Chestergate at that time this does indicate a windmill somewhere near the centre of town at this early period (see 'Windmills'). After the barley grains had been dried in the kiln this is where they would have been ground. They would not have been ground fine, but left coarse, which again enhanced the taste of the beer.

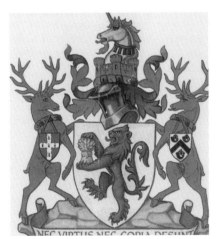

The Macclesfield Coat of Arms of the Borough of Macclesfield, in use until the local government reorganisation of 1972, when the borough was considerably enlarged. Reproduced by kind permission of Macclesfield Council.

The Sixteenth Century

In his book *A History of Brewing*, published in 1975, H. S. Corran provides some interesting information on brewing in general.

During the sixteenth century, in Edward VI's reign, alehouses, inns and taverns were licensed by Acts of 1552 and 1553. Alehouses only served beer and ale; inns additionally provided bed and board, while taverns still sold liquor, beer and ale and sometimes also provided accommodation. A survey of 1577 proved that the sale of beer and ale predominated; there were nine alehouses to every inn and forty to every tavern.

And, although the records are not complete, they do reveal that the counties of Yorkshire and

Nottinghamshire had far more licences than any of the other English counties.

The Tudor Period confirmed England as a great beer drinking nation, with ales drunk on feast days, holidays and whenever an excuse could be found to celebrate.

There were Midsummer and Whitsun Ales to bring in the seasons. Cuckoo Ales to celebrate the arrival of the first cuckoo of the year. Bride Ales when the bride sold ale to her friends on her wedding day in return for gifts of money. Tithe Ales where bread, cheese and ale were given to tithe payers by the person entitled to receive the payments.

Late seventeenth-century leather jugs displayed in a Midlands inn, reproduced by kind permission of the owners.

Court Leet Ales for the feasts held at the Court Leet of the manor for the members of the jury and tenants.

Nor was the religious establishment neglected; Church and Cleric Ales were sold for the benefit of a particular church or clergy, although these celebrations came under threat of suppression from time to time.

The Kiln

On a rental list of Henry VIII's reign a kiln is recorded on Kiln Street Macclesfield, now identified in a property deed under its subsequent name-change to Back Street, which today is King Edward Street Kiln Street seems to be the same one mentioned at the time of John de Macclesfield in the centre of town. It has previously been suggested that the details, transcribed in 1611, were possibly incorrect and referred to a miln (mill). It has also been suggested that if they were correct, then it was probably a kiln for producing domestic pottery. However, given the already established trade routes from the town, and the important early pottery industries of Derbyshire and Staffordshire, this is extremely unlikely. Also the already established and popular beer brewing industry both of Macclesfield and Tudor England adds weight to the idea that the kiln was used to prepare the malting.

The Seventeenth Century

During the seventeenth century stricter regulations were brought in. To begin with, in 1604 parish constables were given the responsibility of inspecting alehouses and the authority to take action in an effort to curb drunkenness; this was followed a tax of 4*d* a quarter on malt in 1614 imposed by James I. But however this affected other areas, it seems to have had little effect in Macclesfield, for within a generation a minister called Revd Burghall wrote his piece.

Edward Burghall of Nantwich was renowned for speaking his mind, and he was a strong Protestant soon to support Oliver Cromwell and his Parliamentarians against the Establishment. Writing on the sin of drunkenness in 1631, he highlighted an incident in Macclesfield:

> This Year there were 5 Aldermen of Maxfield who meeting at a Tavern, & drinking excessively of Sack and Aqua Vitae [suggested to be the same as a French eau-de-vie!] 3 of them dyed the next Day, & the other 2 were dangerously sick. Oh! That Drunkards at last would learn to be wise!

This somewhat enhances the tale told almost two hundred years later by the historian, John Corry, when describing the old guildhall. Apparently the Corporation coat of arms over the entrance hung, which consisted of a lion 'grasping a wheatsheaf' together with the motto, *nec virtus nec copia de sunt* (lacking neither courage nor plenty).

This had been mistaken by a tippler (selected from the OED as meaning 'a habitual drinker of intoxicating liquor') 'for the sign of an alehouse'.

By 1637 further legislation was brought in and Corporations were allowed first refusal of malting and brewing. If they chose not to do so, then they could elect someone locally in their stead.

With the onset of the Civil War in 1642 a beer tax was imposed by Charles I which helped to finance his army. Almost a decade later (1653) the tax on domestic brewing was abolished during the Commenwealth period.

Possibly as a result of all this mid-seventeenth-century legislation, one family came to dominate the beer brewing of Macclesfield, this was the Pickfords. Although they have already been mentioned in previous articles in connection with their various business activities, it is essential that their important role in this particular sphere should not be overlooked.

The Pickfords

On 4 December 1629, James Pickford (former mayor of Macclesfield 1626/27) a tanner by trade of Pickford Hall on Parsonage (Park) Green, together with two accomplices, George Johnson and Roger Toft, appeared in court at Chester. Their crime: they had erected a handmill or quern in Wildboarclough to the detriment of the three Macclesfield mills.

Pickford had family connections in Derby and admitted supplying the inhabitants of Macclesfield with Derby malt 'as others had done'.

Malting was the principal trade of Derby, from where supplies were sent to 'the greater part of Cheshire, Staffordshire and Lancashire, with a considerable portion taken to London 'by which many good estates have been raised' (a comment written by a historian, Mr Woolley, in 1712).

The Castle Inn on the left is a present-day reminder of the influence of the Pickford family and their seventeenth-century malt trade in the area of Backwallgate.

Best Beer

In the northern parts of Derbyshire and Staffordshire, malt was frequently produced from oats, making the ale or beer more laxative than that made from barley. Peas and beans were also malted and occasionally rye. The best beer was made from two sorts of barley, the sprat or long-ear and the battledore, so named because of the flatness of the ear. Having selected the best barley it was placed in cisterns, some of which were made of cast lead. The barley was covered in water for three or four nights, then tested by crushing between the fingers; if the husks rose the water was 'well drained off'.

The barley was next spread upon a 'Couch' floor (the bed or layer on which the grains were spread) about one inch thick in a warm season, but in a hot season a 'Plaister' floor (which presumably meant a hard floor) so it could be spread thin. It was then covered with a hair cloth and, according to the season, was stirred with a casting shovel twice a day in cold weather, but up to six times a day in hot weather. This prevented the rootlets matting together when germination was underway.

The drying process could take anything from seven to fourteen days, according to conditions, and it was then stored in sacks and could be transported. This natural drying process was preferred in Derbyshire, but elsewhere malt kilns were used for quicker drying, with wood considered the best fuel.

When needed this malted grain was taken to the mills and crushed, with the coarser parts put into separate sacks for beer brewing, and any spent grains kept for animal feed. It was this process which had brought into the Macclesfield 'arena' James Pickford, a member of a family that was to grow in importance while making a substantial contribution towards stimulating the commercial interests of the small borough.

Monopoly

After discussion, the case against James Pickford and company was dismissed, and it would seem that until 1660 the Pickfords had managed to gain the monopoly of beer brewing from the Corporation.

Between them, James Pickford and his son served six terms as mayors of Macclesfield for the period 1626 to 1656. In 1665, the year of his father's death, the son James bought the residence of the Earl of Derby on Mill Street from the Corporation. (It had been sequestrated by the Parliamentarians after the beheading of the earl in 1651, and his son, unable to pay a considerable fine and seen it pass into possession of the Corporation.)

The deed of 10 July relates to the house and a courtyard in front of the house, a shop, a malting house and a shed 14 yards long and 4 yards wide, with a wall 3 feet wide and 33 yards long separating the two. Another wall continued from a gate down to a dye house (this has been located on Water Green). The position of the malting house suggests that it was near the present Castle Inn premises (in the early nineteenth century known as The Old Bull's Head in Wellmouth) and conveniently also near the town well.

Having defended the pre-Commonwealth charge of the 'mill' in Wildboarclough, which had resurfaced during the Restoration when old scores were being settled, the Pickford beer brewing business was now expanding in the hands of James the younger.

By the early eighteenth century it was the, grandson John Pickford, who had inherited the several properties and lands in Macclesfield which were leased to tenants, as he was living in Ashton-under Lyne. By then a large malthouse had been erected near to the 'Great Barn', which stood on a site somewhere at the rear of today's Indoor Market (Grosvenor Centre) on Churchill Way. On a deed dated 3 July 1721 the tenant of the malthouse was a George Chantry. This seems to have replaced the malthouse in Backwallgate and would be near the malt mill owned by the Corporation on Dog Lane.

This Corporation malt mill is later referred to as a hand malt mill, a probable replacement for the old windmill, which had stood on the nearby earl of Derby's land.

With the turn of the century the direct involvement of the Pickfords in the beer brewing industry of Macclesfield was at an end, but the seed had been sown and once again other individuals, including the mayor, aldermen and burgesses, saw the opportunity to make profits.

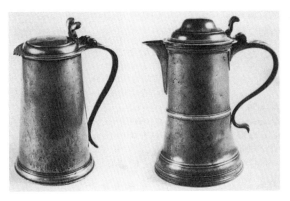

Eighteenth-century flagons: left an early flat-lidded tankard from Northern England, right a later half-gallon ale jug made in London.

The Eighteenth Century

By 1700 there was a considerable variety of beers available, many having been developed throughout the previous century. By then the common brewers (i.e. those producing for several victuallers) had gained ground, resulting in the depletion of the smaller brewer who produced beer for his own business. This process had been slower to come to the northern counties, but had certainly reached Macclesfield by the mid-seventeenth century with the dominance of the Pickford family, which suggests encouragement from the Corporation already mentioned.

After the Restoration in 1660 the town officials slowly but surely regained control of the business and having built their own malt mill on Dog Lane (site of the indoor market area today) in March 1694, obliged the inhabitants within the borough to use its facilities.

This had the effect of taking business away from the Sutton corn mills on Mill Green, much to the chagrin of Lady Fauconberg. The mills were the Old King's Mills of Macclesfield manor, under lease from the sovereign to the Fauconberg family of Sutton Hall.

Lady Fauconberg legally challenged the Corporation over the issue in 1728; the outcome is not known, but the slow decline of Sutton mills would see them converted into silk manufacturing premises about a century later.

Advances

The years 1700–50 were an important period for the British brewing industry. Technical advances were being created and many of today's famous brewers were already developing large premises. Unfortunately, although actual recipes are extant they do not reveal the quantities of the ingredients, but do indicate that hops were now being included with barley more and more, and that ale and beer were two quite distinct drinks.

In 1734 the first publication of *The London and County Brewer* appeared, and although anonymous it was a great success and printed many more times. The quality of the water was, as always, stressed, and the malt from northern counties considered the best. Hygiene was also insisted upon, with brewing vessels cleansed and scalded.

And with the enthusiasm for scientific experiments accelerating, the brewing industry began to claim its fair share of patents. Having visited the Patents Office in London, it is interesting to discover that three-quarters of all patents registered in the eighteenth century relate to the last quarter of the century. This demonstrates how a vibrant period of innovation it was.

The most successful brewers of the period were those making porter, which was a 'highly hopped' dark beer. The inclusion of hops in the brew was the result of the strong links between South West England and the Netherlands; the taste for the hopped German beers was growing.

By 1750 the developing copper industry was able to provide large copper utensils, and there is little doubt that by 1760, with the establishment of Charles Roe's copper smelter on Macclesfield Common in 1758, the company would be in a position to provide the necessary utensils for local industries.

Supplies

It is also imported to realise just how essential beer and ale were with regard to public health. Although Macclesfield Corporation had become involved with supplying water from the 'Round Fountain' on

the common to borough residents in the late seventeenth century, very few were initially able to afford the luxury. With the town well in Wellmouth 'stopt up' in 1736, reckoned as prejudicial to health, many would prefer to continue drinking beer and ale with their meals, a habit acquired over many generations.

In fact, as many manufactories (today the word has been shortened to factories) increased in size, it became the norm to include a brewhouse or to have a supply of beer in barrels from a local victualler on the site. This was equivalent to today's works' canteens.

The days of the beer festivals had virtually disappeared, but casks of ale were provided for employees to celebrate some great success or an important local event, as in the instance of Charles Roe & Co.'s workmen finding a rich vein of ore in a new mine, or a successful candidate in a local election. Barrels of beer were also used as bribes on occasion by a prospective candidate, before the voting in an election had even begun!

During the second half of the eighteenth century common brewers had rapidly taken over from the individual ones.

A Macclesfield Directory of 1818–20, produced for visitors and business people arriving in the town, lists 61 taverns and public houses together with three breweries. Directories cannot be completely relied upon for accuracy of content, some often repeat the same information years later, but they are a useful guide to the nature of the town at a particular period.

The three brewers listed were Thomas Airey of Park Green, and a William Paxton also of Park Green with Bent & Caldwell at the Sutton Brewery on the Common.

The Georgian period was almost at an end, and with an incredible increase in the population from the 1790s to 1825, the remainder of the nineteenth century was about to witness an absolute mushrooming of pubs and licensed premises, particularly in market towns such as Macclesfield.

The Black Horse

Paul Wreglesworth, Neil Richardson and Alan Gall have provided much valuable information in their two booklets *The Pubs and Breweries of Macclesfield* published in 1981 and 1990 respectively, particularly with regard to the nineteenth and twentieth centuries. I have no wish to duplicate their excellent efforts, but where new information arises, as in the instance of the Black Horse referred to from the mid-1850s on the corner of Churchside and Church Street, it is of interest to write about it.

This small street on the south side of St Michael's Parish Church, now known as Church Side, was previously called Churchyard Side.

Name Changes

Now the premises of a chartered surveyors, the building was at one time home to an early inn called The Leopard; this then became The Star and finally The Black Horse. The deeds are very clear on these changed of name, in fact one 22 December 1845 reads:

> All that dwelling house ... used and occupied as a public house theretofore called or known by the name or sign of The Leopard but now by the name or sign of The Star ... in Macclesfield in a certain street called Church Yard Side or Church wall gate [the previous name of Church Street]...

The deed continues by listing the names of several succeeding tenants.

When Isaac Finney wrote Glimpses of Macclesfield in ye olden days in 1883 he referred to the Star Inn as having a date of 1588 in the stonework, which is not surprising as the site next door, now solicitors offices, has at least been occupied from the early 1600s.

A sale notice of 1834 describes The Star Inn as adjoining the Market Place and fronting two streets, which is confirmed by the deed above of December 1845. With the development of Church Street the entrance of the inn on that side was obviously blocked off, and possibly slightly reduced in size to accommodate part of the row of buildings built on the western side of Church Street.

The earliest record of The Leopard Inn is on a deed of 1822, but it could have been in use as an inn earlier. A Macclesfield Directory of 1825 (as previously mentioned these were produced for visitors and business people arriving in the town) lists The Leopard on Churchyard side. This creates a small mystery because Pigot's earlier *Directory of Cheshire 1818-20* lists a Star Inn on Church side, which then only referred to the street on the northern side of St Michael's Parish Church, but no Leopard Inn.

The most likely explanation is that when the old guildhall was demolished together with many old adjacent buildings, in preparation for the building of the present town hall, the original Star Inn was also demolished. The town hall was completed by 1825 and could explain why the directory of that year, while listing the Leopard Inn, does not list the Star.

The white building on the right is what remains today of the Black Horse Inn on Church Side.

At that time the owner (he was not the tenant) of The Leopard was Henry Verdon. When he died his will was published 28 June 1829 and the property was left to his widow, Mary. It seems logical to suppose that about this time the name was changed to The Star Inn as a reminder of the earlier one on the other side of the parish church. The property remained tenanted.

Shortly after her husband's death Mary leased part of the garden to a boot and shoe maker by the name of John Timmins, and on this ground he built several dwelling houses.

Little more than six months later, on 22 December 1845 Mary remarried. Her husband had not only owned the inn but also two or three properties adjacent and a piece of land at the rear of the properties. All these Mary sold to John Timmins with the consent of her husband's trustees. At that time the Inn was still known as The Star.

Timmins Tenancy

Having sold The Star Inn near to the parish church with the adjacent land and buildings to John Timmins a boot and shoe maker on 22 December 1845, Henry Verdon's widow Mary went to live in Manchester

with her new husband, Thomas Surr. The sale price was £750 which John Timmins agreed to pay as a mortgage to the trustees.

Timmins had previously been a tenant of part of the premises for some time, and having also leased a piece of land behind the inn, he had been given permission to build on it. The six houses and buildings that were built became known as Waters Green Terrace.

By this period the town clerk, Thomas Parrott, had his own legal practice in the premises on the eastern side of the inn on churchyard side. Today these premises are still occupied by a firm of solicitors with the address now known as Churchside. At one time the occupier of the property immediately behind these premises had the right to convey a water course from his property to John Timmins by way of a gutter, however, having been offered compensation, which he had accepted, the gutter had been removed by an agreement of April 1820.

Loans

Timmins unfortunately had overreached himself and, with the subsequent appointments of new trustees in Manchester, by late 1870 he was in a precarious position. He dealt with a company of leather merchants trading as Messrs Peverley & Blakey of Dantzic Street in Manchester and, in addition to his original mortgage he was indebted to them for £873 with a further sum of £300 by way of a further mortgage on the property.

Timmins pleaded to be allowed to continue in business if he temporarily assigned to them his properties in Macclesfield, but on condition that when circumstances improved they would be reassigned back to him. This was agreed and as a consequence the extent of his investments was revealed. Not only were the six houses on Waters Green Terrace conveyed, but also the seven houses (some used as shops and the inn) on the eastern side of Church Street together with two moss rooms he had acquired on Danes Moss.

The latter were a medieval right for the provision of peat to be used as fuel etc. Originally each owner of property in the small borough had been given the advantage of working one strip of peat land on Danes Moss; each strip was known as a moss room. These had obviously been traded over the years leading to modern-day complications (some would consider these

38 places to get a drink in 200 yds!!

The 'Black Horse', Churchside, which closed in 1922. The local justices argued that with 26 fully licenced houses, one beerhouse, seven off-licences and four clubs within 200 yards, the premises were not required. The building is now occupied by a firm of Estate Agents.

advantages as the recent proposed development of the area had to be abandoned due to ownership difficulties).

Although Timmins appears not to have owned the properties relating to the Moss rooms, by purchasing them he presumably gained the advantage of either leasing them out or using them for his own benefit. The properties to which they related were a very old dwelling house known as The Mermaid public house on Barn Street (now part of Churchill Way and Exchange Street), and a house on Back Street (now King Edward Street). These moss rooms, one of which is described as lying near Butty Way (?) were each slightly more than 1 acre and 2 roods, although one was a little larger than the other.

As a Cheshire acre, before the enclosure of land in the late eighteenth century, was more than twice the size of a statute acre (each county had its own measurement) this probably relates to an approximate entitlement of originally half a Cheshire acre for each property.

Within a short space of time John Timmins filed for bankruptcy on 24 December 1872. It was then revealed that in addition to his other loans he had initially taken out a further mortgage in May 1845 of £250 with interest from a Daniel B. Curwin.

After the bankruptcy all the properties owned by Timmins, were transferred to the County Court in Manchester. Mr Hines was appointed trustee and released the premises to Peverley & Blakey, leather merchants of Manchester, to whom Timmins owed a large sum of money. Whils retaining most of the properties, the leather merchants sold the Black Horse on 10 September 1874 for £120 to Richard Clarke a brewer of Reddish near Stockport.

There was a concession of a right of way along a covered passage at the side of the inn, behind the property built on the corner of Churchside and Church Street. This led to an ashpit in which the landlord could tip his ashes from the fire grates in the inn; the deed, however, specified 'but for no other purpose'.

Over the years Clarke rapidly expanded his business and obtained a loan of £20,000 from London Bankers by conveying several properties on 20 August 1913. Again the owner over-reached himself and in order to pay off part of the mortgage, made an agreement with Thomas Latham of Macclesfield to purchase the inn for £300.

Latham, a glass and china merchant of No. 52 Mill Street, seems to have applied for a transfer of licence but was refused by local magistrates. They argued that there were thirty-eight places where people could drink within 200 yards, and a previous landlord had been convicted of allowing betting on the premises – although several years before. The inn was closed for several months, but Latham went ahead with the purchase by mortgage of 21 June 1923 with the Leek United & Midlands Building Society for £250 plus interest.

He died 12 October 1940 listed as an Earthenware Dealer and wife, Rose inherited the business. She remarried but died in April 1945 having appointed her second husband, Thomas Howett and an antique dealer. Frederick Fox as executors.

Fox bought the premises, now No. 47 Churchside, for £150 with a mortgage from Martins Bank Ltd. By 1948 the property was recorded as a dwellinghouse, shop and workshop when a cabinet maker and relative of Frederick Fox bought the premises.

In April 1973 the premises were owned by David and John Gittins, 'agents for furniture components'. By 1978 they were living at No. 15 park Lane, Macclesfield and leased part of the premises to a solicitor, Peter Austin.

Alterations were carried out and an outbuilding was demolished to make space for a two room office extension. By 1981 Austin owned the premises and leased offices etc. firstly to a company trading as estate agents, valuers and surveyors, but now as the owner of the property the company is trading as Chartered Surveyors only.

Victoria Park

Today the area covered by Victoria Park began life as part of the forest of Macclesfield. After the Norman invasion of 1066 William Icreated the earldom of Chester and, together with certain privileges, gave it to one of his loyal followers. This included the manor and forest of Macclesfield and succeeding earls held it in service to the sovereign until the middle of the thirteenth century.

In 1253 Henry III, having problems negotiating a marriage between his son, Prince Edward and the young Princess Eleanor of Castile, needed to increase his share of the proposed marriage settlement. Some years earlier, in 1237, he had taken the opportunity to seize all the Cheshire assets of the then earl, when the latter had been poisoned. Rumours suggested that the Earl's wife was the culprit, and intrigues followed which the king then used to his advantage, but subsequently he had been unable to legally finalise the acquisition of the earl's assets. Now he was in a position to 'persuade' certain individuals that the Cheshire estates should be given to his heir Prince Edward; his move succeeded and Edward became earl of Chester.

With his mission accomplished the marriage took place and Henry welcomed his new daughter-in-law to England. It was the result of successful negotiations from which Prince Edward was able to allow his wife the benefit of the manor and forest of Macclesfield together with certain other estates upon their marriage in 1254.

Henry died in 1272 and Eleanor, now consort and queen, had as her forest bailiff a strong and reliable character by the name of Thomas. He was distinguished by the addition 'of Macclesfield' the family having taken its name from the manor.

The northern end of Victoria Park with its monument.

The Francis Dicken Brocklehurst monument in detail.

Hurdsfield

In 1274 Thomas found himself in dispute with the burgesses of Macclesfield, the predecessors of today's Corporation. It concerned a piece of land in Hurdsfield covering 6 acres. He had to appear before the court at Northampton, but the outcome meant that he had to acknowledge the right of the burgesses to the plot of land and convey it to them.

The name Hurdsfield seems to be a corruption of two Old English words that had survived from Anglo Saxon times, *herde* meaning herd, and *felde*, field. When two separate German words are joined together it is usual to put a letter 's' between.

In 1515, just two years after the devastating Battle of Flodden in which James IV of Scotland was defeated by young Henry VIII's army, Roger del Rowe was granted three small pieces of land in Hurdsfield. The battle had deprived Macclesfield of many young and important local family members, some burgesses, and it would take a very long time for the town to recover. With a depleted Corporation this could be the reason why Roger, whose family had provided aldermen and mayors to the town for almost 200 years, was given the opportunity to take possession of the three small Corporation lands in Hurdsfield, sanctioned under law by the manor and forest court. One of these included 'a certain place fenced … and lately hedged'. These small areas to the north, south and west of land he already held in Hurdsfield, created a larger estate.

Another reference indicates that the piece of land, where the herd of forest stags was kept yearly, 'beying and lying' in the forest enclosure from May Day until 14 September, had become known as the Fence. To this day the name has survived with Fence Avenue as an appropriate indicator of the area in which the deer were kept, and was almost certainly part of Roger del Rowe's land.

The Fence

As Macclesfield recovered and the population once more increased, deforestation took place with the deer moving to higher ground, creating pasture which no doubt was used for the grazing of sheep. There is a reference to a medieval dwelling built on the land, which indicates the beginning of what would eventually grow into a much larger estate, always referred to by the name of 'The Fence' or 'Fence House'.

The original tenant of what later became part of the Fence estate was possibly Queen Eleanor's forest bailiff Thomas of Macclesfield, who had tried to consolidate his position with the acquisition of an additional 6 acres of land, only to have been legally forced to surrender it to the aldermen and burgesses of Macclesfield in 1274.

The bowling green in Victoria Park in what was once the ornamental garden of Fence House.

It would be another 250 years before the records indicated that the land was finally consolidated when Roger del Rowe, in the aftermath of the battle of Flodden, took legal possession of the Corporation acres adjoining his own.

During 1893, when Fence Avenue was created and Fence House itself pulled down, the foundations of a much older house were revealed, including fragments of a doorway judged to be of sixteenth century origin. This suggests that Roger del Rowe had probably been responsible for its erection.

There is a Roger del Rowe recorded as mayor for the years 1550–52 and again 1555/56, and is likely to be the same person or a very close relative. It is interesting to note that no mayor is recorded for the three in between years of 1552–1555. Young Edward VI was king for the first period, but Queen Mary took the throne in 1553 when England again reverted to Roman Catholicism. This could have affected the position of the aldermen temporarily, because over the centuries the Macclesfield area has tended to be more puritanical with regard to religion, and at that time Corporation members were bound by the Established Church laws.

Some of the sixteenth century building remains had been used as rubble in the wall of the later house. These included a stone emblem of the Trinity in the shape of a wheel six and a quarter inches in diameter. The three smaller circles evenly spaced and worked around the rim contained the words *Pater; Filius; Spiritus Sanctus* (Father, Son, Holy Ghost) and the emblem had apparently been set above a doorway.

The New House

By 1728 the older building had been demolished and a new one built 'recorded on the beautiful Georgian spout-heads of the period'. The house was the product of a marriage between Edward Blagge of an important local family with connections in Cornwall, and an Elizabeth Janney. The four trustees, two on behalf of the bride and two representing the groom's family, witnessed the property deed on 3 August 1728. Interestingly, one of the trustees was a William Brocklehurst, gentleman of Macclesfield, a member of a family whose name would later become synonymous with silk and with the Fence Estate, particularly during the Victorian period.

Edward Blagge and his wife died without leaving a surviving heir, so the property passed to Edward's brother William. He and his wife Anna left just one daughter Elizabeth to inherit. As this child was a minor an intriguing chain of events then took place and can only the briefly mentioned here, although the full story can be found in the book about the life and times of Charles Roe.

Elizabeth seems to have come under the guardianship of a very important Macclesfield lawyer, John Stafford, who lived in what is now Cumberland House on Jordangate. John Stafford became tenant of the Fence estate, but let it to his daughter, Sarah and her husband Harry Lankford who was a partner in the Roe silk mill.

A very handsome photograph of Thomas Brocklehurst, the first member of the important silk family to own Fence House. The present whereabouts of this portrait is unknown.

John Stafford had important connections in Liverpool, and apart from being responsible for the manor and forest court on behalf of the Earl of Derby, he also worked personally for the Earl, sometimes travelling to the Isle of Man to oversee any legal work there; the earl was Lord of Man. Because of

the Liverpool connections Elizabeth met and married a Liverpool banker, Thomas Smyth who would become a partner in Charles Roe's copper company.

In late August 1775 a dreadful event took place in Macclesfield; the respected lawyer John Stafford of Cumberland House in Jordangate died tragically. During 1777 his son William, a solicitor of the same address also died.

At this time William's sister and her husband Harry Lankford were living in Fence House, the former Blagge estate, but William's death appears to have encouraged the couple's return to Cumberland House until matters could be resolved. This allowed Thomas Smyth to take possession of the Fence Estate on behalf of his wife, the former Elizabeth Blagge.

Smyth Family

Thomas Smyth was an important member of Liverpool Corporation, a partner in a large banking concern, and also a partner of Charles Roe & Co. of Macclesfield from 1774. There were coal seams on the Fence estate, an added advantage for the copper company whose smelters were a few hundred yards to the north along Black Road. Although the Hurdsfield coals were not of a particularly high grade, they could be mixed to advantage with those arriving from other areas such as Disley and Poynton. As a consequence the company proposed a survey from which a lease was drawn up.

With Charles Roe's death in 1781 a replacement was needed to supervise the works on Macclesfield Common. A few months later a character called Abraham Mills arrived in Macclesfield to take up the challenge. He then leased Fence House and the estate from Thomas Smyth, and wrote an interesting account of the collieries.

Unfortunately with the outbreak of hostilities against France, culminating in the Napoleonic Wars, the economic situation deteriorated. Thomas Smyth had already transferred his company shares to trustees in 1789 so there could be no conflicts of interest between his position in Liverpool Corporation and the copper company. He was, however, declared bankrupt by 1791.

Charles Roe's son William allowed Thomas the use of his large house in Toxteth, near Liverpool, but in 1794 Smyth and his wife returned to Fence House in Macclesfield to live, he died there on 12 July 1824 aged eighty-seven years. Thomas left two sons, William (the eldest) was professor of modern history at Cambridge and inherited Fence House and estate. In 1839 William gave the piece of land for the building of Holy Trinity Church at Hurdsfield and its surrounding graveyard, out of the estate,

Edward (the younger son) inherited his mother's valuable jewellery, household contents and residue of the estate, and remained at Fence House for three years presumably as his brother's tenant. In 1827 he moved and as a consequence sold many of the contents he had inherited including the livestock, farm equipment, a handsome gig, beds, chairs, fenders and many other items. The valuables, however, such as the china and silverwares he appears to have taken with him.

Brocklehurst Gain

At this time the house was let to Thomas Brocklehurst, who was a tenant for many years until he purchased the estate from Col. Smyth in 1869 after the death of the colonel's father.

The next to inherit was Thomas Unett Brocklehurst as eldest son, when his father died on 7 November 1870. He lived there with his brother Charles until he purchased the Henbury Estate in 1875. As both brothers were bachelors Charles remained to live in Fence House and was to inherit the property and lands from his elder brother, but fate took a hand and Charles died shortly before Thomas Unett. The latter revised his will and, like all the mid-Victorian wills of the Brocklehursts, set up a very complicated trust for the benefit and education of younger family members. He also nominated two younger brothers, Edward and Francis Dicken as trustees and executors.

The year 1870 proved highly significant for the Brocklehurst family and also for Macclesfield. Over many years they had created a dynasty of silk manufacturers, had kept their mills in production and their workers employed, even during the most critical economic crises earlier in the century when most others had ceased.

The two senior partners, John Brocklehurst of Hurdsfield House and his brother, Thomas of the Fence died within three months of each other, in the summer and autumn of 1870. And the silk interests, although continuing in the hands of the younger members, would never feel the same 'hands on' approach again.

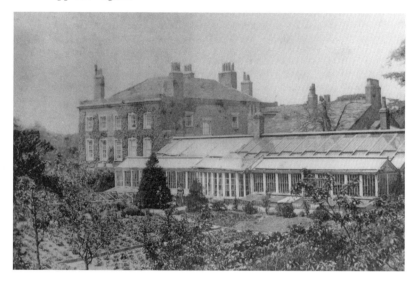

Fence House and part of the beautiful garden before demolition, courtesy of the Macclefield Museums Trust.

Executors

John's son Henry of Foden Bank in Sutton, who was a partner in the Hurdsfield mills, had also died shortly before his father, together with Thomas's wife, Martha. Thomas, having prepared his will earlier had left the use of Fence House to his wife, but as she had predeceased him the Fence estate now passed immediately to their sons, Charles and Thomas Unett.

Charles actually received the house and surrounding garden, but he and Thomas Unett shared the income from other properties on the estate, however, in May 1875 Thomas Unett conveyed all his interests from the estate to his brother, Charles. Thomas Unett had by then completed the purchase of Henbury Hall and consolidated the surrounding estate lands.

In 1882 Charles, a confirmed bachelor all his life, suddenly married a widow, Frances, when he was fifty-five years old. Only eighteen months later he died and by his will she was allowed the use of Fence House, the gardens and contents for life. Any contents including her own personal possessions, which she had brought with her or acquired since marriage, were hers to keep – including the wines and stores. She had also brought £11,000 as her share of the marriage settlement, and now she was to appoint trustees to receive £5,000, the remaining £6,000 was kept as part of Charles's estate, but Frances had to be paid £1,000 each half year for the remainder of her life out of the estate income.

House Contents

It seems, however, that Frances left the property shortly after Charles's death on 20 January 1884, because by the spring adverts appeared for letting the property furnished or unfurnished. Whether or not a tenant was ever resident there is at present unknown, but by July the valuable contents were sold at auction. These included a Broadwood grand piano of walnut, an elegant suite of dining furniture upholstered in maroon leather, fine bronzes, Turkish carpets, oil paintings etc.

The drawing room furniture was upholstered in rich white spun-silk cloth, and the curtains were of damask satinette and cretonne. Hundreds of items were sold from umbrella stands to Tudor and French bedsteads.

The house was advertised as containing an entrance hall, drawing, dining, morning, billiard and smoking rooms. There were seven main bedrooms, day and night nurseries, a kitchen, brewhouse, laundry and excellent cellarage. The servants had their own hall and bedrooms. The glass conservatories, peach house and orchard house, all newly erected and shown in the photograph, provide evidence of an extremely attractive property.

Trustees

Charles left most of the Fence estate to a younger brother Edward, who live in Surrey and appointed Thomas Unett as one of the trustees. The other trustee, the youngest brother Francis Dicken Brocklehurst of Hare Hill, was left other properties in Macclesfield town and also Charles's share of the Macclesfield Arms Hotel. With all the complications of the various wills and the need for ready money on occasion, the Brocklehurst trusts must have been a great burden for the trustees. From time to time they sold various plots of land and properties as and when necessary.

In August 1886 Thomas Unett died and Francis Dicken, once more appointed a trustee, determined to fulfil his eldest brother's last wishes, although not specified in the latter's will.

Following the death of Thomas Unett Brocklehurst in August 1886 his two younger brothers, Edward of Reigate, Surrey and Francis Dicken Brocklehurst of Hare Hill near Macclesfield, took on the tasks of his executors.

By the early 1890s Edward, who after some years farming in Australia had returned to England, was by then married and settled with his family in Surrey and had no further interest in the Fence House estate. Perhaps it had remained empty, and France Dicken on his estate at Hare Hill, being local and unmarried, would have felt the burden of ensuring that the house and gardens were not neglected.

Fence Hospital

The Brocklehursts who had remained in or near Macclesfield, had been brought up by fathers who were dedicated to providing what in modern terms would be social and welfare services for the people in the town. And while Thomas Unett had transferred his interests in the Fence estate to his brother Charles, he had retained ownership of the

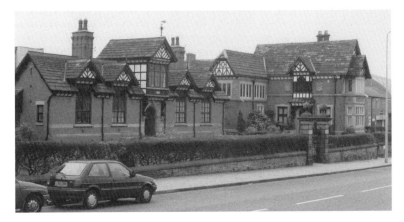

The buildings formerly occupied by the Fence Hospital. The Almshouses and Memorial Houses were originally a gift from the Brocklehursts on Buxton Road.

properties and lands on Buxton Road left to him by his father. These, which included the Brocklehurst charity gift of Fence Hospital, he left to Francis Dicken together with £10,000.

Francis did not die until 1905; he was the last remaining brother and still a bachelor. His will distributed his considerable wealth between many nephews and good causes, but one significant bequest highlights his loyalty above all others. He gave all the properties on the south side of Buxton Road to Edward, son of his brother Edward of Surrey. This by then included not only the Fence Hospital, but also almshouses, memorial houses and premises adjoining and all the furniture and articles etc. This was in the hope that his nephew and his successors would 'continue to maintain the same as a charity in accordance with the wishes and intentions of the late Thomas Unett'.

Francis had obviously completed the buildings that his brother had begun as the date of 1895 can still be seen in the stonework above the main door on Buxton Road. Not only did he provide these essential amenities but he had already made another important gesture. He had purchased Fence House and gardens from his brother Edward by early 1893 and set about making plans for the demolition of the house and outbuildings, the laying out of a new roadway to become Fence Avenue, and the creation of a public park.

The Park

It had been forty years since West Park, the first public park in the town, had been opened, which had proved extremely popular, but more convenient for those living on the west side of the River Bollin. Now those on the eastern side greeted the news with great enthusiasm.

On Whit Monday, 14 May 1894 Francis Dicken conveyed 'all that piece of land ... in Hurdsfield and Macclesfield lately part of an estate called the Fence containing 11 acres 2 roods and 5 perches' to the mayor, aldermen and burgesses of Macclesfield and to be called Victoria Park. This was the day of the opening ceremony.

It was to be used as a public park and recreation ground at all reasonable times. Five acres was allotted as a recreation ground and the remaining six for a pleasure ground.

Public meetings to discuss politics, religion, trade or social questions or 'other matters of controversy or Religious services' were strictly for bidden. Nor would any 'malt or spirituous liquors or any form of refreshment' for which a licence was needed, be permitted. Francis must have agreed to the latter with tongue in cheek, because in his youth he was extremely fond of champagne, but perhaps his many years as a J. P. had had a sobering effect in more ways than one.

A grand procession, including the mayor, town council, clergy, fire brigade, friendly societies and other groups, met at the town hall and together with five brass bands, made their way through the town and Sunderland Street to reach the park. Over 1,000 people lined the route with brilliantly coloured flags, banners and buntings draped on and out of buildings all the way along. The celebrations lasted until well into the evening with a tremendous carnival atmosphere; many people wore exotic costumes and morris dancers were among those providing the entertainment.

At the ceremony Francis handed over the deeds to the Corporation and also a beautifully bound copy of his address. In 1898 his memorial was placed on a granite pillar in the park and can be seen on the photographs accompanying the text.

Granelli's Ice Cream

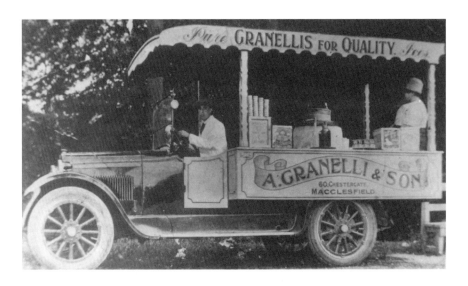

Grandma Maria wearing a very fashionable hat, on her way to sell ice cream at Alderley Edge in the new motor van, purchased in 1924.

It is said that ice cream was first made by the Romans who brought the technique to England. It should therefore be no surprise that Italians have always been renowned for their ice creams, and in Macclesfield none more so than the Granelli family who, like the Arighi and Bianchi families, have helped to provide an extra chapter to the history of the town.

High up in the mountains, close to the port of Genoa, is the beautiful village of Santa Maria del Taro and it was from there, in the 1880s, that Fortunato Granelli made his way to Liverpool. He settled in the great city, then met and married Angela Oliva who was English by birth but of Italian parentage.

Possibly because of the considerable silk trade passing through the port from Macclesfield, suggesting an affluent town, Fortunato came here with his father-in-law Giovanni with the idea of establishing a mineral water business, in which the Oliva family were already involved in Liverpool.

Soon they set up in business at No. 19 Churchwallgate (later Church Street) in 1884 and six years later acquired a sweet shop at No.33 from a Sarah Dale. The business grew and Fortunato brought his nephew Angelo from his home village in Italy to help him produce ice cream, which was created with ice from the Bosley ice works and milk and eggs from local farms. This was such a success that soon they had a stall outside the Central Railway Station and on the market.

Angelo met his aunt's niece, Maria Veronica Corroto who was working in Macclesfield, and married her at St Alban's Church 12 June 1900, just three months after the death of his aunt's father, Giovanni Oliva, until then still a partner in the firm. Just after the marriage uncle Fortunato went off to join the gold rush in America, and the family still recall the photos he sent back, particularly the one where he is sitting on a vehicle outside the entrance to a gold mine. Eventually Fortunato returned to Santa Maria del Taro something of a legend.

Meanwhile Angelo and Maria had three children, one of whom died young leaving Edward and Madelana, the latter known as Madeline in Macclesfield. Shortly after Madeline was born the family left Churchwallgate in 1910 and moved into No. 60b Chestergate, formally part of Charles Roe's house before demolition, and a rented accommodation. They converted the stables behind the house for ice cream production, with an entrance from Derby Street.

Maria took the horse and cart up to Castle Rock at Alderley Edge during the early 1920s. Daughter Madeline walked with the horse on the outward journey because the cart was full and heavy, but if they had a successful day then she happily climbed into the cart and drove back. This much-loved horse called Bessie was put in a local farmer's field for the day. Soon came a motor-driven van, as shown in the photo.

In 1926 the next Italian to arrive from the home village was Guido Devoti. His father had originally carried on an ice cream business in Birmingham, where Guido had been born thirty years earlier. Unfortunately his mother suffered badly from asthma, so when he was six years old they had returned to Santa Maria del Taro in Italy. There Guido as a young man had been compelled to do his National Service, joining the Alpinis, an elite corps in the mountains whose uniform had a very attractive hat with a large feather in it – again recollected from a treasured photo.

Guido, alongside Angelo and other family members, worked hard in the business, and in 1937 married Madeline at St Alban's Church on Chester Road. The five offspring are Eileen, John, Emilio, Delia and Peter, still connected with the business.

The War Years

The war came along and government panic after Dunkirk saw many internments taking place, including grandfather Angelo and father Guido. The family are very philosophical about the episode, and Angelo was soon released because of ill health.

Guido found himself in an internment camp on the Isle of Man, undoubtedly his National Service in Italy had not helped. After ten months he volunteered for farm work, along with other Italians, and was released to work at the Silesian farm in Pott Shrigley near Macclesfield. Officially he was supposed to be resident there, but no one locally ever considered him anything but loyal to Britain, and so he was quietly allowed home at night. Both men considered themselves very lucky, a dear friend was among many Italians put on board the Andora Star bound for Canada, but the ship was torpedoed in the Atlantic and all were lost.

Final Move

In 1945 a milk bar was opened at No. 62a Chestergate (part of Charles Roe House) with a move to the present premises on Newton Street behind the Brewers' Arms public house in 1961 (bought in 1959). Charles Roe House was scheduled for demolition, so the move was imperative. (Fortunately the remaining part of the house was happily reprieved after a great deal of local effort, but by then the move had taken place for the Devotis trading as Granelli's). The milk bar did continue as a business until 1972.

Grandpa had died in 1957 before the move, and Uncle Edward in retired in 1963 and died a year later. Mother Madeline died only in January 2005, just one month before her ninety-fifth birthday. Of the younger generation, today only John's daughter has remained in the business, the other children have branched out into their own individual careers.

I am grateful to the Devoti family for providing the information and photographs for publication.

Prestbury Tithes

The Tudor courtyard of Adlington Hall, a reminder of the days of John Legh before 'modernisation' took place in the mid-eighteententh century under the direction of his son Charles.

On the 19 December 1560 Elizabeth I, by Act of Parliament, granted all the 'tithes, portions and obligations' of several manors in Cheshire (formerly in possession of the Abbey of St Werburg in Chester) to seven large landowners, among whom was Thomas Leigh (Legh) of Adlington Hall. .

His related to the manor of Prestbury with its fields, houses, dovehouses etc. and in addition Thomas also acquired the advowson and Right of Patronage of Prestbury church (St Peter's) together with its tithes. In total he was obliged to pay Elizabeth I a yearly sum of £113 11s 4d.

The tithes covered the whole of the considerable parish of Prestbury which, together with other townships, included Macclesfield and Hurdsfield. And the Legh family were still in possession of these rights and privileges in the eighteenth century, although by this time the Legh family appear to have bought them at an earlier date.

On 20 November 1732 a marriage settlement was agreed for the forthcoming marriage of Charles, son and heir of John Legh of Adlington, and Hester Lee, the eldest of two daughters of Robert Lee of Wincham near Northwich. As was usual there were four trustees, two representing the bride and two the groom.

John Legh had already included the tithes and advowson in his own marriage settlement at the time of his marriage to Lady Isabella, so theirson Charles became tenant in tail. This meant that after the death of his father, the tithes etc. would automatically be considered as having been included in his own and Hester's marriage settlement.

If Charles should die before his wife, then the income from this source was to be used by his trustees for the payment of Hester's dower. A widow was allowed claim of up to one third of her

husband's estate unless other arrangements had already been agreed to in advance, usually legally by being included in the marriage settlement, which had been witnessed and signed by all the parties concerned.

Leases

John Legh died early in 1739 and had reaffirmed the arrangements in his will written in 1734. Almost immediately, in March 1739 Charles leased all the tithes, comprising corn, grain, hay, calves, wool, lamb and 'all other things growing', to two individuals. They related to the manors of Adlington, Butley and Prestbury covering 300 dwellings, 100 cottages, 6 water corn mills, 4 dovehouses, 400 orchards, 400 gardens, 6,000 acres of land half of which was pasture, 300 acres of wood(land), 1,500 acres of moor and heath, 200 acres 'of land covered with water' together with the rents from several townships including properties in Cheadle and Stockport.

Cheshire Acre

This was a formidable holding, particularly as at this time an acre related to a Cheshire acre, which was over twice the size of what later would become a Statute acre. Every county had its own measurement but, towards the end of the eighteenth century, when the Enclosure of land and buildings went on apace, the measurement had to be unified for the whole country. This meant that what had been a Cheshire acre became two and a ninth Statute acres (i.e. the acre that we still use today, although the word 'Statute is now disregarded), in other words 100 Cheshire acres suddenly became just over 211 acres.

This is significant when calculating a probable production figure for that period when the payment of one in ten sheaves of hay, or bushels of corn was handed over, for what was in effect a tax in kind on the tenants. Although there is far more intensive farming today, nevertheless, more grain would be produced then in a Cheshire acre than from an acre today.

Even days of working on the lord of the manor's lands had been included in earlier centuries, but after the Cromwellian years, as industry increased, it became the practice to accept payment in lieu of the previous 'obligations'.

Changes

Within one year of the death of John Legh of Adlington Hall, the trustees of the estate reclaimed the lease of the tithes etc. which his son Charles had granted to two individuals in March 1739. The full income from them was once again included with that for the rest of the estate,

Almost twenty years later the son of Charles and Hester, named Thomas after his grandfather, married Mary Reynolds from Strangwitch, Lancashire. Unfortunately Thomas did not live long and had no children. His widow Mary was to receive £500 each year, paid in equal quarterly instalments, while Charles, her father in law, lived. The money was to be paid out of the tithes, which were now apparently received in money and not in kind as previously (i.e. every tenth lamb, or every tenth bushel of grain etc) from the tenants.

Charles Legh died in 1781 and a complicated situation arose. His widow Hester moved to the city of Chester and claimed dower of £4,000. His niece Elizabeth, daughter of the notorious tax collector, Sir Peter Davenport who had died some years earlier, inherited the estate for life.

She had married John Rowles of Surrey who, as her father had been, was a Collector of Taxes. Together they borrowed the £4, 000 with which to pay Hester, and promised to pay the interest on the loan. Unfortunately Elizabeth outlived her three sons and grandchildren, so that on her death in 1806 the estate passed through the female line to the Crosse family of Shaw Hill, to the west of Manchester in Lancashire.

The mid-eighteenth-century north wing of Adlington Hall, part of Charles Legh's 'modernisation' of the Tudor Hall. This wing overlooks the beautiful rose garden and maze.

The Crosse Family

Richard, son and heir of Thomas Crosse, changed his name to Legh to become entitled to the tenancy for life, and his son Thomas Crosse Legh was tenant in tail until his father's death.

Over the years as trustees had died or resigned, or on occasion one or two had even refused to accept the position, they had been replaced by their heirs or other responsible individuals. By this time the two trustees, William Davenport and John Glegg held a large sum of money from timber sales which should have been invested in land purchases. Richard, however, asked them to pay off the £4,000 debt plus interest and a further £3,000 of outstanding legacies from Charles Legh's will.

By 1822 the trustees were the bankers Daintry & Ryle and a further trust was created with other trustees to raise £10,000 from timber sales to clear all debts, At this time the tenants 'all or a greater part' of them disputed the payment of tithes, so Richard decided to take legal action. As it was for the benefit of himself and his son, they agreed to share the costs two-fifths to Richard and three-fifths to Thomas.

Richard died in August of that year, and the situation had become so complex that one of the trustees, Thomas Drewer of Brighton, presented the suit in the High Court of Chancery. Thomas Crosse Legh died in 1829 with the case still under investigation after submission to the House of Lords on appeal. In 1830 the Master of the Court issued a report and still there was procrastination until January 1837, when he placed two adverts in the *London Gazette* and other newspapers 'circulating in London & the Country for all persons claiming to be creditors of Thomas Legh to come in and prove their Debts'. The Accountant General had the unenviable task of sorting out the legitimate claims, and finally on 31 Jan. 1846 the tithes were auctioned off in Lots. Those for Hurdsfield ultimately came into possession of the Brocklehurst family.

My sincere thanks go to Mr Johnny Van Haeften for allowing reproduction of information from early Brocklehurst deeds in his possession. Further details from the collection will be used in connection with several more properties in and around the Macclesfield area, but reserving the Brocklehurst information for their story, which hopefully will be published in due course

Swanscoe Estate

Henry III

From the reign of Henry III in the thirteenth century the forest of Macclesfield, on the eastern side of the borough, had been in possession of the crown. It had seen a procession of royal kings, queens and princes very much concerned with its affairs; which included, not only its administration and preservation, but also its facilities for the hunting of wild boar etc. and sport such as archery and falconry.

After Henry IV's seizure of the throne in 1399, shortly followed by Richard II's mysterious death, the forest came to be regarded as an asset for revenue. Already there was a court in existence called the Hallmote of the Forest, created to deal with any enclosure of land and any changes of tenure within its boundaries. These were called copyhold tenancies because the tenants had to obtain permission from the lord or the lady of the manor and forest in order to occupy their desired tenures. This depended on who at the time had been granted the privilege of holding the forest by the sovereign, which was either by marriage settlement, in the case of a king or prince's wife, or by leasing to a royal favourite. The tenant had to appear in person at the court session with two trustees and a legal representative to present his claim.

After a second appearance, in which a fee (known as a fine) was paid, the change of tenancy was registered on a court roll and a copy given to the tenant, hence the name copyhold which legalised the claim.

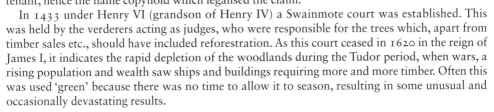

Part of the present Swanscoe Hall with an incredible view across the valley towards Lower Swanscoe farm. Only remnants of the original house remain.

In 1433 under Henry VI (grandson of Henry IV) a Swainmote court was established. This was held by the verderers acting as judges, who were responsible for the trees which, apart from timber sales etc., should have included reforestation. As this court ceased in 1620 in the reign of James I, it indicates the rapid depletion of the woodlands during the Tudor period, when wars, a rising population and wealth saw ships and buildings requiring more and more timber. Often this was used 'green' because there was no time to allow it to season, resulting in some unusual and occasionally devastating results.

Enclosures

During the vagaries of the early seventeenth century small enclosures in Macclesfield Forest were on the increase, and a year after the Commonwealth parliament seized power in 1649, a court leet of the manor and forest was created to deal with petty crimes, showing the extent of infringements and copy holdings within the area, This court lasted until the middle of the eighteenth century.

During this period there came into being three estates 'in the several townships of Hurdsfield, Rainow, Bollington and Sutton called Higher Swanscoe, Lower Swanscoe and Endon'. They stretched from Higher Hurdsfield northwards to Bollington.

Initially Swanscoe was one large holding, a farm and land in possession of a William Watson by the mid-seventeenth century. He died on 23 April 1671 leaving his properties to his son Edward, and others as trustees for the benefit of his widow Ann. By then there were eight houses, three cottages and gardens, 60 acres of land, 40 acres of meadow and 60 acres of pasture. These were, of course, Cheshire acres equal to almost 340 acres today. The fine in the Hallmote was duly paid.

On 8 December 1692 Edward's son and heir William claimed the properties on the death of his father. Five years later William's marriage settlement was drawn up in December 1697 in which he promised that within six months of his marriage to Elizabeth Kinsey of Blackden, he would transfer the estate to the trustees for the benefit of any heirs. William and Elizabeth had a son, Edward and a daughter, but the transfer was never made.

By this time the Watsons were in financial difficulties.
On 6 March 1720 William, with permission from his wife's trustees and, of course, the Hallmote, transferred Swanscoe House with its orchard and garden and 125 Cheshire acres to a John Hussey by way of mortgage for £300 plus interest.

Misfortunes

William Watson had obviously retained part of his Swanscoe estate for the family's use after allowing John Hussey to purchase Swanscoe house and adjoining land on mortgage in March 1720. This was possibly the farm Lower Swanscoe with the remaining 35 Cheshire acres and other small properties, which would be leased to tenants.

His son Edward still held this interest when his parents died, but by that time he had become indebted to several people. He was a warehouseman, an employment described as that of a tradesman or retailer buying imported raw silk and distributing it to manufacturers and also imported Italian and French silks.

By the 1720s the Derby silk mill was importing its own raw silk, and damasks, broad silks, velvets and brocades were now being produced in England, particularly around London. Small wonder that Edward was in trouble, even owing his business partner Nicholas Little the considerable sum of £100. Soon he was declared bankrupt on 22 October 1725 and the trustees for bankruptcy were forced to advertise the premises for sale by auction on 29 May 1727.

The highest bidder was a John Boulton at £605, but before he claimed the property Edward was obliged to recover Swanscoe house and land because John Hussey could not repay the mortgage and

Lower Swanscoe farm, once part of the Swanscoe Estate.

now owed £335 plus interest. It seems obvious that in order to repay the sum Hussey would have had to take out a mortgage with someone else. As soon as this was done the property was transferred to Boulton and he compensated Hussey for the £300 value, but would have recovered the interest due.

Within a few days on 10 June 1727 a Roger Boulton paid Watson £140 for a life interest in the estate. The tenancies were normally for three lives, usually the husband, wife and youngest child, with the hope that the latter would survive the longest. While these three lives were still in being the Hallmote could not remove the copyholder, but once all the lives had ceased a new copyholder could be admitted to the property.

Sometimes it was possible for another close relative or associate to purchase a life interest if one of the original three had died. Although seeming unlikely in this case, John's brother Roger had been able to do so, possibly because he had not been able to attend the court hearing in time and Watson had taken his place for convenience.

The Boultons were a Wilmslow family and also connected with the silk trade. Roger's son, Roger the younger was a chapman, employed as a middle man doing business between the local producers and the large merchants, and at this time Wilmslow was very much part of the silk circuit. The Boultons were obviously succeeding where the Watsons had failed. In 1731 John Boulton bought a neighbouring cottage and a small piece of land tenanted by Edward Downes. These were added to his Swanscoe estate and cost Boulton £30.

The Birtle's Sale

On 17 April 1736 a marriage contract was drawn up for John Boulton's eldest daughter Ellen and Thomas Birtles of Birtles. By this date a family tragedy had occurred, most likely due to an epidemic of smallpox which had been sweeping the area for some two or three years past. Not only had Ellen's father died, but also her uncle Roger and his son of the same name; by her father's will Ellen inherited the Swanscoe estate.

One cannot help but consider the fact that Thomas Birtles seized an excellent opportunity. He was also involved in the button and silk twist trade, particularly in Leek and Macclesfield (full details in my book *A Georgian Gent & Co.*). Thomas included lands in Birtles and Henbury as his share of the settlement, while Elizabeth and her trustees, one of whom was the notorious tax collector Sir Peter Davenport, included the Swanscoe estate. However, Thomas was already in debt and Edward Downes loaned him several amounts totalling £300, which meant that yet another saga was about to begin.

The remaining original part of Swanscoe Farm, once the home of a mining manager.

Like the Watsons before him he had overreached himself in his attempt to make a fortune from the button and twist trade of the area. There was no alternative but to sell his properties and those acquired through his marriage, a decision taken by either the marriage settlement trustees or himself, to which the other party had agreed.

Again it was a sale by auction to take place at the Angel Hotel (the site now part of the Natwest Bank premises) in the Market Place, Macclesfield, on 14 November 1752, with further particulars to be 'had of John Stafford' lawyer of Cumberland House.

At this time Macclesfield did not have its own newspaper so an advertisement was placed in those of Chester, Manchester and Derby. This contains significant details which the deeds do not.

For Sale

First there was the house in Macclesfield 'fit for a gentleman' with its outbuildings and lands etc. This was bought by Charles Roe – now Charles Roe House on Chestergate, although most of the land and buildings have long since been sold and redeveloped.

Secondly came the information regarding Swanscoe, which at that time comprised three copyhold farms described as in Hurdsfield, Rainow and Bollington. One was tenanted by Hezekiah Rhodes, rent £36 per annum (Higher Swanscoe) the second by Thomas Pickford for £20 per annum (Lower Swanscoe) and the third by Thomas Cooper at £9 per annum, the latter was probably the cottage and land known today as Swanscoe Farm (N.B. not Lower Swanscoe Farm).

But the selling point, not as yet mentioned in the deeds, was the existence of 'a considerable amount of timber, coal mines and stone quarries'. The coal works were let at £12 10s per annum, the stone pits at £3 per annum, which, it was stated were 'likely to continue (or better) many years'.

When all the debts were added together Thomas Birtles owed an incredible £3,360. Charles Roe paid £1,370 for his estate, while Francis Jodrell paid £1,600 for Swanscoe. This left Birtles still owing £390, and although a considerably reduced sum, was still not inconsequential by today's values, so finally the trustees sold all the Birtles' goods and chattels 'to set against the debts'.

Business Deals

Francis Jodrell had only five years in which to enjoy his investment. His widow Sarah Mary proved his will in 1757, which allowed her the benefit of the estate, but granddaughter Frances and others were to inherit. Frances would have been left her share to include in any future marriage settlement if necessary, or if she remained single, for her own use. In June 1757 she sold her share to her elder sister's husband John Hookham for £1,700.

After each transaction relating to the estate, the customary appearances were made in the manor and forest court and the fine duly paid.

On 14 September 1782 Thomas Ward and Thomas Wardle, partners and manufacturers of buttons and twist, bought the whole estate. By this date the Higher Swanscoe farm was named as Swanscoe Lodge, which suggests that modernisation had taken place and it was a much grander residence. The stone quarry, which had been leased to a William Henshaw for 5 guineas each year, was now leased to Daniel Nixon of Hurdsfield. There had, of course, been other tenancy changes over the years, and these would continue with Wardle and Ward sharing the profits equally.

In November 1788 they leased both Higher and Lower Swanscoe to a James Bloore of Ipstones for £88 per annum, and by this date considerable progress had been made in the development of the collieries.

The Coal Mine

Although Thomas Ward and Thomas Wardle had leased both the Higher and Lower Swanscoe estates to James Bloore of Ipstones in November 1788 for £88 per annum they retained the rights

of 'digging for coal', 'felling trees for timber' and making roads. The latter was to enable carriage of the valuable commodities in the partnership's new venture.

Various conditions were set out in the deeds safeguarding the use of the land occupied by James Bloore e.g. not to dig or break up the land or convert into tillage (the preparation of the land for growing crops) or in summer to sow with corn or seed of any kind or plant with potatoes during the last six years of the lease, unless Ward and Wardle agreed.

The usual stipulations with regard to keeping all the buildings on the estates in good repair were also included.

After three years however, in March 1791, the two men must have realised that the coal mining business was an entirely different proposition from that of their button and twist manufacturing. They agreed a lease for the colliery with William Clayton, member of an old Macclesfield family who lived in 'Titherington' and was a cotton manufacturer.

Swanscoe was now occupied, not only by James Bloore, but also a Joshua Clark, the latter presumably subleasing from Bloore. Clayton's lease was for a term of forty-two years and contains some very interesting details.

The charges were to be 8*d* a pit quarter, (this was reckoned as 27 hoops to a quarter), from the Smart Seam which was situated in the Lodge Brow (part of Swanscoe Lodge estate).

The charge was 1*s* for every quarter measure (presumably one quarter cwt) from the Smart Seam also called the Great Limit.

It was 1*s* per quarter of 30 hoops to a quarter from the Shore Seam end and for a new seam not yet named, if the coal was found to be at a depth of 50 yards from the surface. If less than 50 yards then then it was 1*s* for a pit quarter of 27 hoops.

Clayton was allowed free coal for the fire engine to be placed on the premises, this would probably be to drain the mines of water. He was also allowed the first 1,000 quarters of first coal 'he shall get out of the Shore seam' as a contribution from Wardle and Ward towards expenses for enlarging and cleaning the sough which they had still retained.

The first payment was to be on the day the first coal was raised and then on the second and last Saturdays of each month.

Swanscoe Hall once the centre of an important mining business.

Wardle and Ward could appoint a banksman or winder and a collier to work underground, and send someone into the pit to examine the works when necessary. Clayton, however, was to pay the banksman and collier the same wages as those received by other pit men elsewhere.

Everything had to be left in good order when the lease expired or was given up, and all the equipment, including the fire engine, had to be left on site, unless Wardle and Ward refused to purchase it at a fair market value. The engine house also had to be left in good repair but was not to be included in the valuation.

Thomas Ward died and his will was proved in Chester in June 1810. Although the colliery is not specified in the will, his son Gervase was to inherit all the interests his father might have at the time of his death, which apparently included the colliery.

26 October 2006

Gervase Ward, having inherited his father's half share of the Swanscoe colliery business in 1810, soon had Wardle agreeing to sell him the other half share of the mine. In addition to this Gervase paid Wardle £1,500 for the other half share of Swanscoe Lodge and the stone quarry, previously in the occupation of William Henshall who paid a rent of £5 5s per annum. This meant that Gervase owned the whole of the Higher Swanscoe Estate and the colliery, the latter still leased to William Clayton.

At some point in time, the smallest and most northerly property, Swanscoe Farm, became a mine manager's home. A derelict mine made an appearance not too long ago, and is located just a stone's throw to the rear of the building. The horses of the owners were in the adjoining small field, with a ridge topped by a fence between them and the mine. The horses habitually galloped to that side of the field but their movements disturbed the ground and the top of a hidden mineshaft caved in, with some serious consequences. The field was still owned by The National Coal Board, which immediately undertook a survey and arranged for a small team of men to rectify the situation.

As they began the task of filling in the shaft, unfortunately each in turn became ill because of fumes emitted from the workings. Work stopped and a full investigation took place, then to everyone's surprise it was discovered that a well-known pharmaceutical company had polluted the mine with waste material.

The stable block of Endon Hall, now converted into cottages, The only remaining original part from William Clayton's ownership.

The previous owner had agreed to the waste disposal not realising its toxicity. A court case sorted out the issue with the company obliged to rectify the situation. Fortunately the owners of the farm had rejected an offer from the National Coal Board to buy the adjoining field for £1 when they first moved in.

Endon Estate

Today a man-made ridge runs in a northerly direction towards Endon Hall from close by the farm. This had originally been created, presumably by William Clayton and his workmen, to accommodate a rail track on which wagons full of coal ran through the adjoining Endon Estate to the top of a steep hill. From there it was redirected down a second track, eventually terminating at the side of the Macclesfield canal, which was opened for traffic in 1831. Exactly when this rail track was created is not mentioned in the property deeds, but the completion of the canal by Thomas Telford could have been the inspiration for the idea. It could also have been the initial impetus for William Clayton to buy the adjoining Endon Estate in 1833, and then create the rail track. This track would also accommodate the quarry, which is situated at the top of the hill. Clayton's success at the colliery saw him converted from a cotton manufacturer of 'Titherington' on his lease of 1791 to a coal proprietor of Adlington when he signed the Endon Hall deeds on 4 March 1833. The Endon Estate was described in the eighteenth century as four tenements in Bollington with closes known as Horse Race and the Common Lands and a cottage in the village. For many years it had been used as an investment by merchants in and near Manchester, having been the subject of several marriage settlements and included in wills, thus passing from one relative to another.

By 1819 it was owned by William Acton Okell Whitelegg and his sister Mary Ann, late of Heaton Norris then of Manchester. The three surnames in William's name are a good indicator of the families who had been involved in the ownership of the estate over many years.

Interestingly, Mary married James Cockson, an important surgeon of Macclesfield, but she tragically died in 1826 without children so the brother was the heir-at-law because she had not made a will. When William Aston Okell Whitelegg's sister died in 1826 he inherited her share of the Endon Estate in Bollington. During the year prior to her death, however, William had already sold his own share to a John Vaughan of Heaton Norris near Stockport. Vaughan now agreed to take the whole estate.

Roe Windmill

As Vaughan could not directly pay the money, he had borrowed against his own estate, intending to sell some of his properties in Heaton Norris to defray part of the purchase costs for Endon.

By December 1829, however, after offering these properties at Public Auction 'no one bid a satisfactory price', so Vaughan offered the Endon Estate to William Clayton for £8,400 at 4 per cent. This also included part of an estate called Oak, which was conveniently situated on the northwest side of the route along which the Macclesfield canal was being constructed, which opened for traffic in 1831.

The sale was finally completed on 5 March 1833 after many complications during which Vaughan had accepted the involvement of trustees to cover his loans.

Full of enthusiasm, William Clayton began to develop the Endon lands and properties. He built cottages and even bought Charles Roe's windmill, originally constructed on Macclesfield Common, for grinding calamine ore for the company brass works; this was re-erected close to his stone quarries.

While still on Macclesfield Common the windmill had been converted to a corn mill by 1801, in an effort to make it more viable for selling. The economic effects of the Napoleonic Wars were gradually becoming more and more devastating. In 1813 the mill had at last been sold to a Bollington miller, William Boston, who built adjoining cottages and was still in possession of the properties on the common in 1830. As this is the last mention of the windmill on Macclesfield Common it suggests that Clayton probably bought it within a year or so of acquiring the Endon properties.

Above and bottom right: This steep gravel pathway was the original rail track, created by William Clayton down to the canal side, and one of the wagon axles which was discovered buried at the side of the pathway.

Above right: The remains of the Roe windmill, once part of the Endon Estate, before demolition in the 1940s. Courtesy of A. Rowbotham.

There appears to be no given reason as to why Clayton decided to buy the windmill from the miller, perhaps he considered it as an enhancement for his Endon estate; it is fortunate that the deeds record the purchase and have helped solve another of Macclesfield's long sort after answers.

Legalities

By 1841 Clayton was forced in turn to obtain a loan, which was part private and part from a bank in Manchester. Deeds were drawn up to include the loan, which showed the original properties and lands purchased as the Endon estate and incorporated the additional cottages and specified the windmill as that built on the land by William Clayton since his purchase of the Endon Estate.

A year later Clayton borrowed more money, owing a total of £7,000 but he had kept up the payments of interest. He now realised that it was important to make financial arrangements in case of his death as he was no longer a young man, so he bequeathed the business to trustees.

Of the two selected, one seems to have been connected with the Manchester bank from which he had borrowed part of the money, while the other, who lived on the Isle of Man, presumably represented the private part of the loan. Clayton also engaged the solicitors, Brocklehurst & Bagshaw of Macclesfield to act in a legal capacity for him.

On 23 July 1850 William Clayton died. Both his widow and his male heir David Shaw Clayton died in 1873 and the estate and business passed to his great nephew, Thomas Rylance Gibson, a barrister of London.

Endon Hall today; much rebuilding has taken place since the days of William Clayton.

During 1866 a gas pipe had been laid from Bollington Gas Works to Endon House and other properties in the village, and an agreement signed for further pipes to be laid through the estate. These were continued through neighbouring land belonging to Frederick Richardson, to join the gas main of the Bollington Local Board of Health at the canal bridge near Bee Hive Hill. At last Bollington was modernising.

The London barrister had already borrowed money against his inheritance from a Miss Ord of Tunbridge Wells, in the sum of £13,900. In order to pay the interest on the debt he had borrowed further from another individual in the legal profession in London, which created a total debt of £15,000.

Although Gibson was able to make some payments against the loans, by 1875 the situation had reached a climax. The property was valued at £16,000, so together with trustees and Miss Ord a decision was made to sell. At this point Peter Pownall Brocklehurst of Hurdsfield House, a banker and son of the former silk manufacturer John Brocklehurst Esq. MP bought the estate as an investment. He paid Gibson the £16,000, who in turn paid off his loans of £9,100 and transferred the property to Peter Pownall on 22 June 1875.

Consolidation

Meanwhile, the adjoining estate of Swanscoe, inherited by Gervase Ward in 1810, had been left to his three sons after his death in 1816. During 1821 his eldest son Thomas bought the other two shares of the estate from his brothers, but during 1830 he was compelled to use the property as collateral in order to acquire loans. This time it was John Norbury of Prestbury Hall who invested his money, and on 4 September 1838, with Thomas Ward unable to pay his debts the property was legally transferred to Norbury.

This transfer of property did not include Lower Swanscoe, and there Thomas lived until his death in December 1854.

By this time the new owner of Swanscoe lodge was a Philip Holland, who once more added Lower Swanscoe to the Swanscoe estate by purchase. In 1856 he approached Peter Pownall Brocklehurst for a loan, and in return allowed his a one sixth share in the estate.

After Philip Holland's death in 1873, the estate passed to other family members, who in turn borrowed money.

By 1880 Peter Pownall Brocklehurst had gained a further two-sixth shares, which gave him a half share interest in the property. He had, of course, already bought the adjoining Endon House estate five years earlier. During the following year of 1881 a further loan and a further transfer

of one-sixth was made, but the banker then decided to play safe, and in 1885 transferred all the loans to the Union Bank of Manchester Ltd.

The colliery lease continued and was now in possession of a Mr Needham, and the remainder of the property was divided between several tenants, from whom the bank collected the rents. Finally on 19 April 1898 Peter Pownall Brocklehurst purchased the whole of the Swanscoe estate for £10,000 from the Union Bank of Manchester Ltd.

Once again the former Higher Swanscoe, now Swanscoe Lodge, buildings and lands, together with the Lower Swanscoe farm and lands, and the whole of the Endon estate were reunited under one ownership, and this provided Peter Pownall Brocklehurst with a formidable investment.

Red Squirrel Saga

The year 2006 was designated 'Red Squirrel Year'. This provided an opportunity once more for articles of a rather vitriolic nature to appear in a magazine and newspaper with regard to Thomas Unett Brocklehurst and also the son of one of Thomas' cousins, Henry Courtney Brocklehurst. Both came under suspicion of acting in an irresponsible manner with regard to wildlife, but what are the facts?

Did Thomas single-handedly cause the almost complete annihilation of our English red squirrel population by introducing two grey squirrels from America onto his Henbury estate? Thomas was born at Fence House, today remembered by the avenue called Fence. He never married, and in later life remained with his brother Charles in the family home

A Red Squirrel – watercolour and water soluble wax crayon by Brenda Hooper, member of the Macclesfield Art Group.

until he bought Henbury Hall and grounds for £9,000 in June 1874. In 1877 he was high sheriff of Cheshire, and as a consequence claimed a coat of arms for the family just before leaving for a world tour early in 1879. By this time he was fifty-five years of age and, being a most meticulous man, set down in the greatest detail many of his experiences during his travels.

Henbury Hall. The hall was the home of Thomas Unett Brocklehurst from 1874 till his death in 1886; it was later demolished and replaced by the present domed building. Courtesy of the Macclesfield Museums Trust.

He visited India, China, Japan, and then sailed to San Francisco. Next he journeyed south to Mexico, at that time predicted to become one of the world's most important countries. Nowhere does he mention the acquisition of two grey squirrels.

From Washington Thomas travelled by train to New Orleans, from where he would take a boat across the bay. The town was crowded as the assizes were in session, but he managed to find a not too auspicious hotel and ate supper, which he thoroughly enjoyed. Having helped himself to another plateful, he enquired what sort of fowl the dish had been prepared from, but on hearing squirrels he dashed to the bar at the other end of the room and had a stiff (here *expliqués* followed). This is the only time squirrels are mentioned.

In every country visited he gives a detailed account of people and situations. He was particularly concerned about justice and the poor, and the condition of animals. He was welcomed by peasants in Japan and Mexico, and his experiences in China when visiting a prison leave one in no doubt about his compassion and concern for those suffering in the most unfortunate and appalling conditions.

If he did return home with two grey squirrels, perhaps thinking that they would become extinct on the American continent because of the popularity of squirrel pie, why are they not mentioned? Also the idea that he kept them in a cage to entertain his friends is entirely out of character.

As early as 1828 grey squirrels had been released in the United Kingdom in fairly large numbers, and Woburn had been responsible over the years for at least nine such occasions, one of which was in Ireland. The drastic decline of red squirrel numbers was from 1900 to 1930. The reasons are too numerous to mention here except that their favourite habitat of pine forests was drastically disappearing.

The Giant Panda

And what of Col Henry Courtney Brocklehurst, game warden of the enormous territory of the Sudan for several years, and protector of the white rhinos? 'He worked tirelessly in all seasons, studied the game and found out all that was necessary to protect and improve various rare species.' So why shoot the panda now on display in West Park Museum?

It has often been related that Henry Courtenay went missing in Burma during the last war in 1942 on a secret mission with his Special Service detachment, and never returned.

At the time he went to China in 1935 the Communists were infiltrating from the north, and he went behind their lines to the Red Basin of Sichuan. There he shot the panda, then not considered a rare species. What better way to report back on what was taking place in that vast country?

The panda was for a time exhibited in Berlin and Hermann Goering no less, took such as interest in it that he wanted it to remain there. Has anyone ever considered that Henry Courtney was on an intelligence mission to find out about the Nazi's rise to power? Having return to England, with his offer of the panda being refused by the Zoological Society in London, it was placed in the family's museum in West Park.

As a director of London Zoo, the break out of war and risk of bombing in 1939 caused him great concern for the animals. He arranged for the evacuation of some species e.g. zebras, camels, wallabies etc. to the family's Swythamley Estate, just over the border in Staffordshire. Unfortunately 1939 was one of the most severe winters on record, with several feet of snow, and many animals died. Some wallabies escaped and lived for many years in the Roaches. When last seen the remaining few had moved south to Cannock Chase.

Christmas News

If anyone thought that Christmas holidays abroad, or even taking up residence and working abroad, were a modern idea, think again.

Apart from local news *The Macclesfield Courier and Herald*, which had first been published in 1811, was always anxious to report news from the Continent and also worldwide.

The Napoleonic Wars had greatly disrupted the passion for visiting France and even Italy; and in the immediate aftermath, while there had been an initial stampede, checked by government legislation because of the considerable flow of currency out of the country, by the 1830s restraint was long past, except for self-restraint by the lesser mortals during periods of economic depression.

In December 1832 the Macclesfield residents were treated to a preview of the festive season in Italy by one of the newspaper's correspondents. He reported that the previous year Rome had been a 'desert' with only six English families of distinction enjoying the sights. Now, however, apart from German and Russian families, it was crowded with the English. Some were nobility, but there were others who would have been considered of more moderate means.

The latest arrivals, listed by name, ranged from several earls to many vicars and even a Mrs Greenwood and family. Particularly mentioned are a landscape painter and two saddlers from London, all three being in permanent residence.

While some of the English business people had displaced their Roman counterparts, for example: the London saddlers with their connections in the coach building trade and gig letting, who had made a 'considerable profit', Rome had gained in other ways.

The price asked for apartments was so exorbitant that they thought every Englishman was a Baring, every German a Rothschild and every Russian a Demidoff (a reference, of course, to very wealthy merchant bankers).

Party games Victorian style from *The Illustrated London News*, 1891.

The Marquis of Northampton had let his beautiful villa near to the Baths of Diocesan for a very moderate price to a Mr Crookenden, 'but his praiseworthy example will not be followed by the greedy and rapacious noblesse of this impoverished capital' The excuse used was that the Roman season only lasted three months and they had to make up for the losses of former winters.

Celebrations

Also they were advertising the fact that this particular winter would exceed all the former seasons in gaiety and that three crowned heads would be spending the Carnival there. The first fete before Christmas was to be given by the King of Naples on his arrival with his bride from Turin. It would be on a very grand scale and probably take place either in the Palazzo Farnese or the Teatro Aliberti because of the large numbers invited.

The previous week an Italian Duchess had given a splendid ball at the Tortonia Palace and a Mrs Jackson, had organised a *soirée dansant* the previous evening at the Casa Pinciana, which was attended by all the foreign ministers and their ladies.

Meanwhile, in the more subdued festive atmosphere of Macclesfield, the only piece of information that was likely to draw attention was the fact that on the previous Tuesday solicitor Peter Browne had invited a number of 'poor and decrepit old women' to his house. There he had treated them to an excellent Christmas dinner of roast beef and plum pudding and subsequently 'a good cup of tea each'. The comment was that 'the old dames enjoyed themselves amazingly', one cannot help but think that perhaps they would have enjoyed themselves even better with a tot of good cheer!

The Pearle Wall

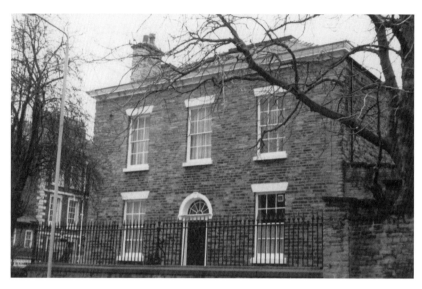

The northern section of Cumberland House, which covers the remains of a seventeenth-century dwelling. This has once again become a separate unit under the present refurbishment, and will be known as Stafford House.

Rowe Family

Having previously written articles featuring Cumberland House, Pearlwall meadow, the Rowe family, John Stafford and the Jordangate area, early deeds have now come to light that provide a far more accurate and comprehensive history of the site.

The first mention of the land on which Cumberland House now stands is on 3 March 1329 when William de Rowe subleased a piece of land and meadow called Pyrle Walle from Jordan de Davenporte. This is now the earliest record of the Rowe family (not to be confused with the later Roe family) and their connection with Macclesfield.

This land would have been part of the manor and forest area of Macclesfield, which was owned by the crown but leased to more local individuals who in turn would sublease. It was situated on the boundary of the ancient borough, which in time would make it a prime target for expansion of the borough boundary when the opportunity arose.

Remarkably during the next three centuries, although there were various chief tenants, the Rowe family always appear to have been successful in renewing their leases. They improved their holding e.g. in 1375 a grange is recorded, which at this time was a large barn in which hay and grain etc. was stored.

They also increased the acreage, as in 1401 when a piece of arable land was leased to extend the northern boundary along the highway to Titherington (Tytherington). Other small exchanges with neighbours took place until eventually two Pearle Wall meadows (various changes of spelling occur over the years) stretched from Back Street or Lane (now King Edward Street) all the way down to the River Bollin along the highway.

The western boundary abutted what is now the eastern boundary of The King's School playing fields, and continued its almost direct course, to finish in line with the western boundary along the ancient lane.

The Rowe family dominated municipal affairs, providing more mayors and aldermen than any other family in Macclesfield's history. One of them, Bryan Rowe, became vice-provost of King's College Cambridge; he died in 1521 and has already been the subject of a previous article.

During the Civil War the family supported parliament against the King, and it was at this time that both the King and the Earl of Derby were beheaded. The Earl had jurisdiction over the manor and forest of Macclesfield on behalf of the King. Lands were sequestrated from anyone considered a traitor to parliament and sold or leased to loyal supporters. This seems to have been the convenient time for the Rowe family to purchase the Pearle Wall estate for themselves.

Discoveries on site during the present alterations to Cumberland House have revealed vital information, which is supported by evidence from the deeds. At some time during the early part of the seventeenth century a house was built covering approximately the northern half of the present main building. From the position of an old exterior wall, complete with windows, which were subsequently bricked up, the house would have faced south towards Back Street and was three stories high, about the same height as the present two-storey building.

This belonged to the Rowe family, but by this time the remaining male heir had left the town and become an alderman in Berkshire. By his will he left his Macclesfield properties and lands to his great nephew, Samuel Harryman, a solicitor of Eaton, and these included the house and meadows of the Pearl Walls estate.

Greaves House

The house originally inherited by Samuel Harryman in Jordangate was known as Greaves

house; the Greaves family had possibly been the first tenants when the house was originally built. They were an important middle class family in the town, and two of them, William and Robert would later become mayors of Macclesfield.

Samuel Harryman and his wife Isabella owned twenty-two houses and gardens, six cottages, ten orchards and 156 acres of land, 10 acres of which were woodland. This combination was no doubt the result of their marriage settlement. And while Samuel Harryman had held the position of mayor in Macclesfield for 1729–30, he had probably lived in Greaves house.

Within the year he had made the decision to sell the Pearle Walls estate to a young lawyer. The name of this young man was John Stafford Jnr who would become an important influence in the affairs of the borough.

The conveyance was finalised on 3 August 1731 when John Stafford paid Samuel £329, and Isabella £1 3s. The payment to Isabella would have been in acknowledgement of the marriage settlement agreement because of which she and her trustees would have had to agree the sale.

The superb original fireplace in what was then John Stafford's drawing room.

John Stafford

It was about this time that John Stafford became deputy clerk to the manor and forest of Macclesfield on behalf of the Earl of Derby, and this is now the earliest connection of the lawyer with the town. Soon he also held the deputy town clerkship of Macclesfield, and his position and work, particularly in the northeast Cheshire area, must have recommended him to William Tatton of 'Withenshawe' whose daughter Lucy he married on 21 November 1734.

During the preceding two years it seems apparent that he had extended and modernised Greaves house to complement Pear Tree House (now Jordangate House) on the opposite side of Jordangate, which had been erected in 1728.

The roof and ceilings of the old house were raised, and fortunately the new half, which was an extension southwards, still retains its superb drawing room with original features, including the Venetian window and fireplace, together with a chinoiserie fireplace in one of the upper rooms. A Hogarth painting of 1736, entitled *The Lady's Last Stake* depicts an almost identical drawing room.

One of the few known portraits of John Stafford, but this is not the one painted in Macclesfield by Joseph Wright of Derby. It was painted by the artist in Liverpool during 1769 at the same time as that of Charles Roe.

The house now faced eastwards across Jordangate towards Pear Tree House, and originally would have had two Venetian windows, one on either side of the door. Also the second storey would have had a row of windows similar to those of Pear Tree house. But John Stafford's house would have been the grandest in town, reflecting his marriage into an important family and the prestigious position which he now held under the Earl of Derby.

Having married Lucy he placed their coat of arms in the hallway of the house, which undoubtedly would have become known as Stafford House. Fortunately the Arms have survived until today, with the crescents representing the Tatton family on the right and the black martlets (birds) of the Staffords of Eyam in Derbyshire on the left.

The coach house remains at the rear of the premises, but the Stafford entrance to the courtyard would have been from the lane now known as King Edward Street. Together with the garden surrounding the house, there were also the two Pearl Wall meadows stretching down to the River Bollin on the northern side.

John Stafford's career advanced as he became clerk to the manor and forest court and clerk to the mayor, aldermen and burgesses of Macclesfield. He also acted personally for the Earl of Derby, at times travelling to the Isle of Man to inspect the Earl's estates there, including a school. He had connection in London, and worked on behalf on the River Weaver Trustees and other clients. He was also instrumental in the business affairs of Charles Roe, as the company grew to become one of the foremost brass and copper concerns in Britain.

Wright of Derby

Now owner of an impressive estate and married to Lucy Tatton, whose nephew 'modernised' Tatton Hall in the eighteenth century, he was included on the Tatton family tree (which is on view at Tatton Hall). It was in Macclesfield that John Stafford and one of his daughters sat for the famous artist Joseph Wright of Derby, while having their portraits painted. There seems little doubt that the artist would have carried out the commission in Cumberland House, for they are

the only two recorded in Wrights papers as painted in Macclesfield. Later, in 1769 the whole of John Stafford's family and Charles Roe had their individual portraits painted by the artist in Liverpool.

After John Stafford's tragic death in 1775, a valuation of his estate was made.

The house had become known as Cumberland House, after the Duke of Cumberland's three day stay in December of 1745. This had allowed time for his army to rest and replenish stores before continuing the pursuit of Bonnie Prince Charlie back to Scotland, resulting in the final battle at Culloden on 16 April 1746. The earlier arrival of the Scottish army on their way south, together with the Prince marching up Jordangate, and John Stafford's part in the traumatic episode of the following few days, has been well documented previously.

Cumberland House

Under the old medieval system, each burgage plot in the borough was entitled to a moss room from which to take peat for fuel, mostly in the area today known as the Moss and indicated by Moss Lane. There was also an addition of a pew in the Parochial Chapel, now St Michael's Parish Church by the seventeenth century. There was no entitlement to a moss room for the property, proving it was not within the boundary of the medieval borough; however, there was a pew, which had been purchased in the chapel, and which John Stafford and his family occupied when attending services.

It was therefore calculated that the house with its outbuildings, yards, gardens and pew was valued at £800, although a later note states that the pew had to be taken out of the valuation. The surrounding land, comprising the Back Street field, the Pearl Walls field and meadow, attracted a very large valuation of £2,073.

John Stafford had also invested in several smaller properties in and around the town during his career, which were all leased to tenants. Four of these, one large and three small had a total valuation of £103 16s., while a large house on Barn Street, now part of Churchill Way, was worth £60. Another garden on Barn Street was held under a lease from Lord Cholmondeley value £20 6d, while the Gallowfields, on the south side of Chester Road, also owned by John Stafford, were estimated at £351.

Additionally he owned three crofts, each with a value of more than £300, and nearer to his house a barn and part of a field on Back Street value £84, and another field called Little Whalley Heys, still retained by The King's School as part of its lower playing field (see *Past Times vol.* II pp 272) £159 6od.

Two more pieces of land in Macclesfield completed his possessions in town, however there were one or two valuable properties in Bollington. For example, Mount Farm (land and buildings worth £3,392) together with Henshall's Farm (land and buildings £298 10s) and Alehouse Farm (£848 5s). Added to these were several other smaller properties in the township, and more than 1,000 acres in the High Peak, the latter inherited from a close relative, another lawyer called Anthony Stafford.

A simple calculation giving a rough comparison with today's values would provide him with assets well over a million pounds. However, things were not so simple.

Climax

After years of hard work John Stafford had been ill for some time before his death in 1775. He had faced many problems in his career; for example, the advance of Bonnie Prince Charlie and his soldiers on their way south to claim the throne for his father exiled in Rome. This had been a tremendous responsibility to ensure the safety of everyone who lived in the town, while at the same time secretly reporting events to the Earl of Derby on behalf of the King. He had also suffered the humiliation of seeing the silk-spinning mill (in which both his son, William, and son-in-law, Harry Lankford had been partners) ruined. They had been declared bankrupt and there remains a slight shadow of doubt over his trusteeship of the estate of a young lady, orphaned at an early age, (all dealt with in my book *A Georgian Gent & Co.*)

Pressure from all sides affected him greatly, and the climax seems to have come while watching a production of one of Oliver Goldsmith's plays, *The Good Natur'd Man*, at the Macclesfield theatre. Having called for his carriage half way through the performance, at a somewhat significant part, he was taken home complaining of feeling ill, and was put to bed.

The next morning the awful news soon spread around the town that he had been found dead with his throat cut, presumably 'by his own hand'. This was a terrible tragedy for such a remarkable man, which affected everyone deeply. It must also have been particularly devastating for his own family, especially son William, a solicitor, who remained to live in the house.

John Stafford died on 29 August 1775, but he had prepared his will some time earlier in March 1773, at the time of the bankruptcy of the silk mill partnership. It revealed much about John Stafford's financial situation in later years, particularly his large borrowing from his in-law Thomas Tatton, against his Bollington estates.

The coat of arms of John Stafford, for many years prominently placed in the hallway of Cumberland House, now retained within the building after refurbishment. The black martlets represent the Staffords of Eyam, and the crescents the Tatton family.

The Debts

The problem had begun in 1763 with the first large loan of £2,500, and was no doubt connected with the large silk mill business of Charles Roe, John Robinson and Samuel Lankford. The latter was the father of Harry, who became the son-in-law of John Stafford. Samuel Lankford had died in 1760 and was replaced by his son Harry.

Charles Roe, having become involved in the copper business from at least 1756, needed to withdraw his investment in the silk concern, as expenses in the former business were mounting. In January 1762 his share was valued at just over £6,000, the same as Harry Lankford, and at this period William Stafford, by then a solicitor, was admitted as a partner with the purchased of half of Charles Roe's share. This must have been achieved through his father obtaining the loan of £2,500 from Tatton.

In 1764 Charles Roe agreed to sell the other three partners his remaining share in the silk concern, one of the largest, if not the largest, in Macclesfield. Depression soon followed, and John Stafford unable to pay off the loan, eventually witnessed the bankruptcy of the mill. In the meantime further borrowing from Tatton reached a total of £3826 32d, which would have attracted interest usually at 4 per cent.

With this extremely large sum owing to Tatton, and a mention of other debts, the valuation on the Bollington estates did not cover. John Stafford requested that the trustees should sell his assets and pay off all debts, but not sell the Cumberland House Estate in which William was allowed to live. Money had to be kept for his two unmarried daughters' marriage settlements, or if they remained unmarried, for their maintenance. It was also necessary for William to be left a small annual income for support, and some of the furniture etc. in the house.

Unfortunately William lived little more than two years after his father's death and shortly after that of Thomas Tatton, at which time John Stafford's estate had still not been settled under the trust. William's will reveals much about his character and, of course, the situation at that time, including an interesting look inside Cumberland House.

Bequests

The first request in William Stafford's will is interesting; he wanted to be buried near to where he died, in a private manner and without bearers 'except such persons as are absolutely necessary to carry me to the Grave and two of my own servants to follow me as mourners and that neither my Seat nor the pulpit in the Parochial Chapel [now St Michael's] of Macclesfield be lined or covered'.

One has to feel a sense of pity for the young man; it was as if the tragic death of his father had also followed him to the grave.

William fulfilled all his obligations to the family with regard to the small monetary legacies, and distributed his personal belongings among friends and family members, including the Tattons. Some items he had inherited under the will of his late uncle, Thomas Tatton. These included a large and a small pair of silver candlesticks, a portrait of his deceased cousin, a two-handled silver cup, a watch and cornelian seal, one coffee pot and writing desk.

After his father's death William, in exchange for receiving all the outstanding sums of money due to his father's legal practice, had agreed to purchase the household furniture valued at £656 18s 4d and had charge it in the accounts. Harry Lankford, husband of his sister Sarah, had agreed to accept a payment of £900 in lieu of any further claims on the estate, so the Lankford interest in the property ceased.

Other items included two large china flower pots which usually stood upon the hearth in the parlour, a clock from his father's room, a silver waiter, silver sauce boats, tea pot and coffee pot, which together with a cream jug had been a present from John Stanley.

To the solicitor, Joseph Cook (whose house in Jordangate is now the Silver Coin premises in the Market Place) he gave two very personal possession; a silver loving cup of his father's and also his father's writing table.

Another important solicitor Peter Wright, apparently held in high esteem, appears to have taken over the legal practice of William and was appointed Clerk to the Manor and Forest by the Earl of Derby, having held the position of town clerk for the town since 1765. He received William's 'longtailed' bay horse and 'Whiskey' harness, the table clock from his room together with the printing press and letters.

The chinoiserie fireplace in one of the upper rooms of Cumberland House, which has fortunately survived from John Stafford's days. Reproduced courtesy of Janhill Ltd.

William had also owned a few pictures, one of himself which hung in the dressing room, and another of Jupiter the dog, which appears in one of his sister's portraits painted by Wright of Derby. He also had a mahogany clothes press (a sort of wardrobe with large drawers) and a washing table.

His law books, globes, maps, bible and silver tankard, the latter a present from a client, he left to his nephew Harry Lankford Jnr 'and whatever school books which may be useful to him for his education'.

The remaining items of furniture, china, linen etc. were left to his two unmarried sisters, who presumably remained in the house until their marriages. Lucy married Samuel Wilkinson of Stockwell, Surrey shortly after her brother's death in 1788. After ten years, left a widow without children she remarried a vicar Revd Sykes. Penelope married a young minister Revd Johnson of Ashton upon Mersey in 1780.

The two families were still in possession of the Cumberland House estate when, on 10 February 1819 Revd Johnson and Revd Sykes, on behalf of their wives, sold the two Pearl Wall meadows to John Brocklehurst Jnr. By that date the meadows had been divided into three, in order to create a garden on the northern side of the house. Both the garden and house were leased to another solicitor, David Browne, who had his practice in Cumberland House. The garden could be entered through a splendid set of wrought iron gates, complimented by a set of five stone steps leading down from the courtyard behind the house.

Restoration

Since writing the Cumberland House article, I am indebted to a reader from Reading who provided a copy of a drawing of the seventeenth century house on the site, (reproduced with some difficulty). The original is probably the one that hung on one of the doctors' surgery walls some years ago; whereabouts now unknown.

The drawing, together with features only recently uncovered during the present sympathetic restoration work, at last reveals a complex and fascinating building which spans several centuries. The main surprise is just how big the seventeenth-century house was.

Greaves House early in the 1730s before John Stafford's 'modernisation' programme drastically altered its appearance.

Having seen the work in progress, and the architects' plans, which have now been updated to take into account the emerging features and the details from the drawing, a more complete picture unfolds.

Internal walls of stone, filled with mortar containing straw and cow dung, and also a small part of a window indicate a long medieval building, which ran parallel to Jordangate. This was more than likely the grange mentioned in early deeds, in which harvested wheat and grain etc. would be kept for the town. From the position of remaining walls, large parts of which were removed during subsequent rebuilding, the barn did not occupy the front half of the house as it now stands on Jordangate, but the rear half. At some point it was possibly converted into a dwelling or farmhouse.

In the first half of the seventeenth century it was incorporated into Greaves House, which was raised to three stories at the northern end and ran parallel to the Backstreete (King Edward Street). The rest of the building, extended on the south-eastern side, appears to have remained two storey, but the complete building complex was parallel to Jordangate, including several long outbuildings at the rear, one of which must have been stables.

A Jacobean-style staircase, recently discovered behind panelling, is to be restored and will remain as an additional enhancement to the property.

Georgian Style

John Stafford's 'modernisation' in the early 1730s produced a more magnificent mansion house, with considerable demolition of outbuildings at the rear to form a courtyard and better access to the stable block from Back Street. This stable block was, by then, built parallel to the street and not to Jordangate as formerly.

The façade was given a Georgian 'face-lift', and the superb drawing room was created by extending the outer wall some 3 feet nearer to Jordangate, to accommodate the Venetian window. This would have produced a symmetrical frontage suggesting a second Venetian window on the other side of the doorway.

The dovecote on the corner of where the chemist shop now stands, was probably built first, before the main alterations, as there is no mention of it in connection with Greaves House. The drawing would have been made at this time and was presumably kept in the Stafford House after the building work was completed.

The next significant reconstruction appears to have been carried out after the sale of most of the land to John Brocklehurst Jnr in 1819. From this time until 1864 the house deeds are missing.

In 1819, David Browne, an important Macclesfield solicitor, was leasing the house and small adjoining garden. About this time drastic alterations took place on the northern section, retained to this day. The 'remodelling' created a separate address, No. 2 Cumberland Street, with two storeys only. This presumably not only conveniently removed John Stafford's bedchamber, where he had died, but at the same time separated David Browne's living quarters from his business i.e. solicitors' offices.

The centre piece depicting an eagle from John Stafford's original drawing room ceiling, fortunately still extant in Cumberland House.

Victorian Times

In 1864, Thomas Parrott, another solicitor, who had become town clerk in 1830, bought the property with a loan of £1,200 from a widow, Elizabeth Turner of Hurdsfield. But whether for his own use or as an investment is not known; his main property was a farm in Sutton. Seven years later, with the capital still outstanding he decided to sell; yet, why the Cumberland House deeds were not handed over to the new owner is difficult to deduce.

Having bought Cumberland House in 1864 for £1,200, Thomas Parrott agreed to sell the property only seven years later on 16 October 1871 to William Bullock for £1,800.

Parrott had paid the interest due on the mortgage for the seven years to Mrs Elizabeth Turner of 'Titherington', but the £1,200 was still outstanding, so it was agreed that Bullock would pay Mrs Turner the £1,200 and £600 to Thomas Parrott.

By this date the property comprised two dwellinghouses in Jordangate and at No. 2 Cumberland Street, formerly the one property Cumberland House; these were occupied by William Bullock and also a Thomas Piddock. In addition Bullock also occupied a house, shop/warehouse adjoining, which became No. 7 Jordangate, of late years the Co-op Society chemist shop. He leased out a further two houses and a bakehouse in Jordangate, but these were not part of the Cumberland House complex and could have been the Old King's Bakery, which was next to the town hall in what is now the Market Place.

Silk Brokers

By September 1887 William Bullock had considerably extended his business to the point where he had overextended. He was now trading as William Bullock & Sons Silk Brokers, having admitted his three sons, John, William and Thomas into partnership. Having a very large mortgage outstanding, (totalling over £29,000, together with a company account of £4,000) the Manchester & Liverpool Banking Co. Ltd , seized the Cumberland House properties, occupied by the sons and also Benjamin Pierpoint, together with No. 7 Jordangate.

Additionally there was a plot of land on King Edward Street covering just over 4,000 square yards on which stood a newly built workshop, office and other buildings, all belonging to the partnership of William Bullock and George Burgess. This site was previously occupied by the Free Grammar School. These buildings had been let to several different firms from time to time, but were now standing empty.

On 24 December 1887 William Bullock was declared bankrupt, and the properties were sold. There is no further mention of the buildings on King Edward Street nor of the two houses and bakehouse in Jordangate.

The three groups of properties i.e. Cumberland House, garden, stables, coach house etc.; the house No. 2 Cumberland Street occupied by Pierpoint and now quite separate, with a fence dividing the front garden on Jordangate and a wall built at the rear dividing the courtyard from Cumberland House; the shop/house and warehouse No. 7 Jordangate, lately occupied by William Bullock, were all sold to Samuel Tomkinson for £1,600.

Tomkinson was a wholesale grocer who soon retired and died, leaving his widow, Rachel in the premises.

Twentieth Century

Rachel borrowed money on a private loan and, apart from her own house at No. 7 Jordangate, leased the other properties as four different lettings as shown by a Valuation of 1914. Cumberland House was leased to Dr J. H. Marsh, surgeon. On 25 March 1919 Dr Marsh bought all the properties, including No. 7 Jordangate from Mrs Tomkinson for £2,500. An interesting note in a schedule of 1903 shows that St Albans Catholic Club leased the stable and coach house room for 5s per week less rates, but there is no indication of the period of the letting.

Dr Marsh became a man of considerable influence as Governor of Macclesfield Infirmary, Medical Officer of Health for the Borough for thirty years, honorary tutor and examiner to the

St John's Ambulance Brigade, and did much to clear slums and improve the water supply in the town. He died in 1929.

On 16 November 1929 two doctors, who would also become very much a part of Macclesfield history, Margaret Leetch and Francis Edward Lomas agreed a mortgage with the executors of Dr Marsh's will. This medical partnership soon became a marriage partnership resulting in a story of a renowned medical practice too long to tell here.

With the construction of the new medical centre on Sunderland Street and the removal of several of the town's medical practices to the building during 2006, Cumberland House is witnessing once more another chapter in its history.

Four dwellings will be created after the huge restoration programme is completed and will be given the names of Cumberland House, Stafford House, Derby House and Greaves Cottage, recalling some of the most important periods in its history.

The modern restored façade of The Bate Hall, Chestergate.

Earl of Courtown

On 18 November 1857 John Brocklehurst bought a small insignificant strip of land from the Earl of Courtown. The Brocklehursts, when purchasing any property, were always very careful to obtain as much information as was legally possible to substantiate their ownership at a later date if necessary.

This was due to the fact that William, the eldest brother, was a solicitor and had been well advised by his London agents (another firm of solicitors in the city) always to obtain the greatest details, particularly title deeds if possible.

While in this instance the sight of title deeds was not possible, yet the resulting abstract of titles reveals another facet and another family of great importance, which were part of Macclesfield's fascinating history.

Stopford Family

The family name of the Earl of Courtown was Stopford, said to have been originally from the medieval name of Stopport, today Stockport. In 1642 James Stopford (Stopport) was living at Saltersford Hall when his son William was buried in Macclesfield.

The property, situated in a remote valley between Rainow and Goyt Forest, had been built in the late Elizabethan period circa 1594 and was therefore a 'modern' mansion at that time. It appears to have come into the family when James married the daughter of a Mr Worrall, and would have been part of the marriage settlement. The family were no doubt merchants and farmers like so many others.

The hills around Macclesfield were home to several dissenters. They preferred to remain on the fringes of the borough in which the establishment, fortified by the principles of the Church of England, held sway.

It is no surprise, therefore, that James Stopford became a colonel in the Parliamentary army when the Civil War began, and for his efforts he seems to have been first rewarded with some properties in Macclesfield.

Burgages

The Earl of Derby not only held lands and property in Macclesfield forest but also in Macclesfield town itself, at the northern end of the borough. He had several burgages, including the 'castle' site and on what is now the indoor market site (i.e. Dog Lane and Barn Street). Others included a cottage and additional buildings leased to a Thomas Stopford.

He could have been related to William Stopford who was a governor of the Free Grammar School from 1674 until his death in 1683. Eleven years later another James Stopford was elected as a governor of the school, but by this time the main branch of the family was well and truly settled in Ireland.

James had proved himself to be a remarkable soldier and had come into possession of several burgages in the borough which seem to have been those seized by the Parliamentary government from the Earl of Derby. The Earl's subsequent execution, and the inability of his son to pay a considerable fine for the reinstatement of many properties, resulted in several being sold to those loyal to the Puritan cause. This could be the reason why, after the Restoration of the monarchy in 1660, many property deeds seem to have conveniently disappeared.

The properties now owned by Stopford included 'All that capital messuage or dwelling house called the Bate Hall in Macclesfield' with its lands and in the occupation of Hannah Mottershead in 1887 as tenant.

The Irish Connection

During the eighteenth century the Stopford family of Saltersford Hall and Macclesfield had gained in significance and importance in Irish affairs. As Colonel James Stopford had done much in support of the Parliamentarians, perhaps he considered it wiser to remain in Ireland after the restoration of the monarchy in 1660. He must have felt that given time the prejudices of the Civil War years would hopefully fade away.

The family certainly worked hard to achieve this and gain favour once more with the English establishment.

Named after his grandfather, it was the grandson of Colonel James who purchased the Courtown estate in 1711. At that time the family home was Tara Hall and the New Hall estate Co. Meath.Meath, through which the River Boyne flows, lies mostly to the north west of Dublin but narrows to reach the coast just north of the city. It is a very fertile county, and for centuries had provided flax and wool to local industries.

The Hill of Tara, cone-shaped and 507 feet in height, was legendary. There the High Kings of the Celtic island were said to have resided, and St Patrick to have met and won a great argument with the Druids.

The Courtown purchase was in Co. Wexford, a coastal county to the south, separated from Dublin by Co. Wicklow. It was there that James's son, yet another James, was created Baron Courtown in 1758, then Viscount Stopford and 1st Earl of Courtown in the Irish peerages of 1742.

His sister married James son of Joseph Stopford, a cousin and captain in the English army. Her husband had been born in London, but he later became bishop of Cloyne in Ireland and was a very close friend of the famous Irish satirist, Jonathan Swift (1667–1745). Swift had accepted the position of dean of St Patrick's in Dublin during 1713.

Beech Lane. Behind the newly built white house on the left, and just visible in the centre of the photo, a new development is taking place on what was previously a strip of land between the foreground property and the gardens of Brynton Road. This was bought by John Brocklehurst from the Earl of Courtown.

Bishop James was appointed an executor of Swift's will and was left a portrait of Charles I by Van Dyke, which he had originally given to Swift.

On the death of this 1st Earl, his son James became the 2nd Earl of Courtown and continued his father's work. He was a founder member of the Knights of St Patrick.

The order was created by George III in 1783; the last knight was created in 1922 when most of Ireland gained independence. Technically it still exists, with the Queen remaining sovereign of the order with just one officer. The Irish government has from time to time considered reviving it.

Membership was only permitted to knights and gentlemen, but the latter had to prove that both their mother and father's families had been entitled to a coat of arms for three generations. In fact only Irish Peers were ever appointed.

In 1907 it received headline news when its insignia, which had become known as the Irish crown jewels, mysteriously disappeared from Dublin Castle shortly before a visit by Edward VII.

It had been presented to the Grand Master of the order by Queen Victoria's uncle William IV, comprising a star and badge of rubies, emeralds and Brazilian diamonds. On special occasions the knights wore collars made of gold depicting harps and Tudor roses, with a crown over the centre harp. The enamelling was white and red, and five of these collars were stolen with the insignia. None have ever been recovered.

Normally the knights wore a broad blue sash with a gold badge sporting a shamrock above a cross of St Patrick.

Having found himself firmly placed in Irish society, James achieved the ultimate family ambition. He was created Baron Saltersford in the 1794 Peerage of Great Britain.

Once more the link with Macclesfield was set on record, and the establishment had forgiven.

Bate Hall

The only other deed that has come to light with regard to Bate Hall is one of 1896 when John Simpson sold it to William Archer Smith. It only refers back only to 1880 when the owner Peter

The strip of land along Beech Lane where a ropery existed in the early 1800s.

Simpson died, but it appears to have been tenanted for some time. The land area included was 2,260 square yards, which stretched from Chestergate backwards to King Edward Street.

In 1810 the 2nd Earl of Courtown & Baron Saltersford died, and the title passed to his eldest surviving son James George, who inherited all the family estates including those in Chester and Macclesfield.

The Irish holdings were considerable in the counties of Wexford, Carlow, Dublin, Kildare, and also in the city and county of Kilkenny.

Obituary

The *Macclesfield Courier* newspaper announced the death of the 3rd Earl on 15 June 1835, together with brief details of his life and family. He had died in Windsor at the home of his brother, Revd Henry and not Robert, as erroneously stated in the paper. As an MP he had taken his seat in parliament as Baron Saltersford, and under two Tory administrations had been captain of the Yeoman Guard. He married his cousin Charlotte (daughter of the Earl of Buccleugh) and had several children by her.

Robert Stopford, his youngest brother (1768–1847), was leading a distinguished naval career. During the Napoleonic Wars he had served on board one of Nelson's ships in the Mediterranean fleet, but missed the battle of Trafalgar when the ship was ordered to the West Indies. However, he was awarded a gold medal for his part in the battle of San Domingo.

In 1808 he became a rear admiral and served with great courage in the Channel during the blockade of French ports. Having rejoined the main fleet in 1809, he commanded in South Africa and then Java and, after promotion to vice admiral in 1812, eventually was appointed Admiral on 27 May 1825.

By 1837 Robert was again in the Mediterranean as commander-in-chief, there to assist the sultan against Mehemet Ali, the latter supported by the French. The situation was difficult, but he recovered the Turkish ships for the sultan, which had been captured by Ali, and saw off the French. He received the thanks of parliament, the freedom of the City of London, a sword of honour from the sultan, and honours from Austria, Prussia and Russia.

Robert's final post was as governor of the Greenwich Hospital from 1841 until his death in 1847.

Beech Lane

By 1857 John Brocklehurst, owner of the Pearl Wall meadows, decided to approach Robert's nephew, the 4th Earl of Courtown, in order to purchase the strip of land of less than 5,000 square yards on the eastern boundary of the meadows near Beech Lane. As the Macclesfield deeds could not be found among the Stopford documents, John Brocklehurst raised objections to the title. However, the Earl and his son John Henry George (Viscount Stopford) heir-in-tail to the estate, signed a bond indemnifying him against any future claims that the land was not theirs to sell. He agreed and paid the considerable sum of £400 for the land.

The remaining strip between his newly gained plot and the lane, is recorded as 'Late Mr Roe's premises' and thereby hangs a mystery. Who was he?

He was Joseph Roe, rope maker and flax dresser, who advertised on 20 June 1812 that he was moving from his grocery business on Mill Street to his ropery on 'Beach' Lane, where his ropes were made; hence the length of the piece of land.

Charles Roe's son Joseph had died at Moody Hall, Congleton in 1820, and his son Joseph, also of Congleton, had died even earlier in May 1817 aged thirty years. Both had been much out of favour with their fathers.

An advert of 2 November 1811 names Roe & Rawlinson partners and lessees of a newly built silk mill near Dog Lane (indoor market), with a Mr Foden sharing the building. By 1817, when the premises were put up for letting, it was Roe and Foden who were the occupiers. This Roe is more than likely either the son or grandson of Charles Roe. However, at present it is not known if one of them also had the ropery. There was another Roe family in the town at this time, but with no connections whatsoever with Charles Roe's family.

Mohair and Silk

Apart from the Bate Hall property on Chestergate, the Stopford family owned six adjoining houses on the same side; on part of the area at the rear of these properties were seven more houses and five cottages. The latter were along Back Street (now King Edward Street) and stretched all the way to Little Street where there was a barn within a yard. This holding covered a large area and, being tenanted, was looked after by a local solicitor.

Between these and Jordangate, while several properties occupied Chestergate, and fronted onto what is today the Market Place, the land at the rear in Back Street was mostly allotments and gardens.

After the passing of the Toleration Act in 1789 a group of dissenters, who were actually Presbyterian at that time (i.e. those who had supported the Parliamentarian ideals) became trustees for the building of a chapel. In 1690 the Dissenting Chapel was built on one of the Back Street plots. Earlier the land had belonged to the well-known Blagg family (of the Fence, Hurdsfield and elsewhere), but had

Portrait of Sir Francis Dashwood, courtesy of the present Sir Francis; print by the Courtald Institute of Art.

recently been bought by a merchant, Charles Yarwood. He was a very important merchant and became one of the elders of the chapel.

The first minister was the famous Joseph Eaton, who was tenant of a house on the opposite side of the street where Bonnie Prince Charlie had stayed during his brief visit in December 1745 (see *Past Times vol. I* p36-40) and not too far from the chapel. This would later become the new Free Grammar School, however the congregation must have felt that they needed to build their own parsonage house.

The Dashwoods

At that time a very important man owned the plot of land between the chapel and the Stopford land. Surprisingly he was Sir Francis Dashwood, Alderman of London, who had no family connections with the town except as a turkey merchant. Founder of the Dashwood fortune and living in Dashwood House (Bishopsgate in the city) through the Levant Co. he imported mohair and also silk, which had crossed the border into Turkey from Persia. In 1679 the Dashwoods were responsible for one third of the silk imported through the East India Co. from India and China; but initially it was the mohair trade that was the most important.

By 1640 the making of mohair yarn for winter clothing employed 'a great body of people' in Middlesex. There garments were lined with shalloon and other woollen materials, and many mohair buttons would be needed for the completed garments. Which merchant or merchants first created the link between the Dashwood imports and Macclesfield is at present

King Edward Street – the plot of land to the right of the car was owned by Sir Francis Dashwood, Alderman of London, in the late seventeenth century.

unknown, but Sir Francis would sell thousands of pound worth of mohair to the town (by today's values). The important button industry had begun its rapid ascent after a much smaller and earlier beginning in Tudor times and was encouraged by the importation of Spanish silk buttons.

Legislation interfered and silk began to gain ground; buttons were now being made of mohair and silk, the mohair sometimes used for embroidered decoration. Finally Sir Francis was sending great quantities of silk to the Macclesfield market to be processed in twisting crofts. This was carried to various places from Stockport to Leek, from Wilmslow almost to Buxton, throughout Macclesfield forest and was, of course, used in the town itself.

At first he and his son had been charged a corporation fee known as 'stallage' for their transactions, but in 1675 Sir Francis paid the considerable sum of £40 to become a Freeman of the Borough, which entitled him to trading rights. This meant that he had first bought a burgage in the town, and that was the one on Back Street.

When Sir Francis died in 1683 he left £100 to the poor of Macclesfield. It is thanks to his considerable trade that the people were encouraged to develop and expand the market; the important button industry and finally the silk trade.

After the death of Sir Francis his eldest son (also called Francis) took over the title. He still held the freedom of the borough and also the plot of land next to the Dissenting Chapel.

In order to build a house on his plot of land, permission was obtained from the new Sir Francis as soon as the chapel had been completed. The house was built in 1692 by Thomas Hudson of Sutton, one of the chapel trustees and on the 6 July of that year he purchased the land and the rights to the house, the latter demanded by law at that time. The payment was £300.

This seems to have been done by him in the hope that he would be recompensed by the chapel trustees, who intended to use it as the parsonage house. However, the expenses for the building of the chapel seem to have exceeded the contributions to the fund of donations, set up to cover materials and actual work done.

Having no alternative, Thomas Hudson, now in debt, sold the property to a chapman called Roger Boulton in February 1697 for £610, but the legalities were not completed until September of that year.

By the end of May 1744 Roger Boulton had died and his son-in-law inherited the house. He was living in Chester and so agreed to sell the property to Hugh Worthington, another of the

trustees, and this time it seems to have been on behalf of the chapel. The consideration was very reasonable, £195.

Circumstantial evidence suggests that the property had become the residence of the dissenting ministers since the time it was built. They would have been tenants, but what the terms were on which they occupied the premises, is not known.

The first piece of evidence, proving that it was the house of the minister, appears on the deed of 1744, which states that it was occupied by Revd Thomas Culcheth. He was one of the longest serving ministers from 1716 to 1751.

An inventory of the minister's house on Back Street, taken on the 15 August 1804, gives an idea of what the building looked like. Headed 'Fixtures & different Articles of Furniture in the House in the Back Street the Property of the Congregation of Protestant Dissenters in Macclesfield & belonging to it', the following details are given. In the cellar were two stillages and several shelves, with some small shelves on the cellar steps. A stillage was a bench or frame which allowed items to drain or dry out before being stored, and it kept them off the floor.

The house had a large porch in which there was both a large and small seat.

In the right-hand parlour was a fire grate, cupboard and four canvas window blinds.

In the 'House place', which sounds like a sort of outhouse, there was a large butter press, four cane window blinds, an ash grid and slop stone. The ash grid would have been a grate which fitted over the ash hole where the ashes from the fires were kept, these were collected periodically by the scavengers (i.e. eighteenth-century dustbin men). The slop stone was a stone slab used as a surface, usually for washing clothes on.

The 'back' parlour only had a cupboard. Intriguingly there were three rooms referred to as 'lodging rooms'. The right-hand one contained another butter press and fire grate; the left-hand one just a fire grate, with shelves in a closet; the back one a large oak chest, a butter press and writing desk.

A room described as the 'Back Garret' contained a white wooden table, three old

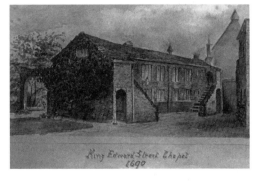

The King Edward Street Dissenting Chapel built in 1690. Courtesy of Eila Forrester.

chairs, two cane window blinds and a pair of bedstocks. The latter were the headboard and foot piece of the bed between which cross staves or rungs were laid ready for the mattress to be put on.

In the space at the top of the garret stairs stood a large oak screen and an old easy chair. The rest of the furnishings would have been provided by whichever minister was in residence.

13 July 2007

The parsonage house for the chapel stood next to it on King Edward Street for many years, but a very interesting letter of August 1865 indicates that it was no longer being used as the minister's house.

Over the years the Brocklehurst family, who were to become famous for their silk production, in many ways had almost become sole custodians for the chapel. In that year of 1865 a new minister was needed, and the choice fell on Revd T. F. Thomas.

Charles Brocklehurst wrote and offered him the post at £180 per annum, payable by the family, but there was no mention made of a house. On 31 August Revd Thomas, while writing his letter of acceptance from the Isle of Wight, gave a wonderful description of a firework display by the Royal Navy at Spithead. The significant part of the letter, relating to Macclesfield, was that he intended staying at the Macclesfield Arms Hotel for a few days while looking for a residence.

The upkeep of the chapel had always been the priority and by this date the parsonage must have been in rather a dilapidated condition, however, John Brocklehurst Jnr found a solution. As MP for the town he was always very concerned about local conditions and worked very hard through the machinery of local government to provide many much needed amenities. The old building was demolished and permission given for a new building on the site.

The Police

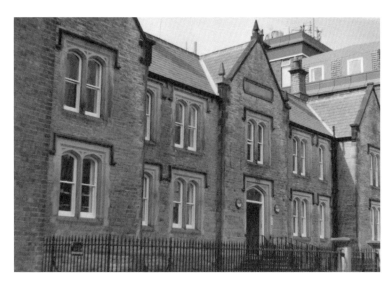

The old Cheshire County Council police station built in 1865–66. This never was the guildhall; the present town hall stands on the site of the guildhall, and it was the Macclesfield police station which adjoined, not the one for the Cheshire County Constabulary.

John Brocklehurst's brother William was a partner in Brocklehurst & Bagshaw solicitors, whose offices stood in front of the Dissenting Chapel on King Edward Street, and they were eventually appointed clerks for the Police Commissioners.

In 1814, during the Napoleonic Wars, the mayor, aldermen and burgesses had been designated police commissioners for lighting, watching and regulating the police within the borough. But there were few constables to rely on in a real emergency, so the yeomanry were the strong arm of the law and were called into action by the mayor, via the lieutenant of the county, when necessary.

Incredibly this left the commissioners mostly with concerns about the water supply and street lighting at that period. Unlike the first established force, the Pool of London police were formed to combat pilfering and crimes along the Thames – especially in connection with the extensive sugar warehouses.

Are water restrictions new? Not by an order of 7 July 1836, which appears in the Macclesfield Corporation minutes, 'that the Town Water be not allowed to the Commissioners of Police for watering the streets in the present scarcity of water'!

The lighting, of course, involved the regulation of a gas supply, in order to light the streets. This seems to have taken up a considerable amount of time, and also the question of the market, which mainly concerned the facilities provided in The Shambles for the butchers.

Another problem that occurred from time to time was the dangerous state of buildings, particularly if a chimney on a factory was declared to be unsafe. Prosecutions could then follow usually dealt with locally.

Petty crime was dealt with by the magistrates at their sessions in the town hall, but serious crimes were tried at Chester. This meant that prisoners awaiting transportation to Chester had to be held in police cells.

Since the 1790s, the rapid increase in population had seen the number of residents in the town mushroom to such an extent, that more central control was needed, and more adequate jail facilities, required.

Complaints

Many complaints had been made about the inadequate way in which the body of police commissioners operated and it was inevitable that something would have to be done.

In 1853 a new police station was built next to the town hall, which was the result of one of those periodic and entertaining sagas in the annals of the Corporation.

The police commission for Macclesfield, originally created in 1814, had initially been formed, not only to control 'Lighting and Watching' but also to take action with regard to the sanitary conditions of the town, which were causing concern.

A decade later they were accused of 'total neglect', particularly with regard to the state of the pavements, which were causing accidents. At this time the public at large seemed to think that the Corporation had given too much attention to their own inadequate facilities in the old Guildhall, which had stood for many centuries on the corner site of the present town hall, next to St Michael's Church.

During 1823–24 the guildhall was partially demolished and the classical part of the present town hall complete with Ionic columns, was built facing St Michael's; the present façade with columns facing Chestergate was created later.

A considerable change took place in the 1830s; first with the Reform of Parliament and then with the Corporation Reform Act of 1835, which abolished the old Corporation and created a new town council.

The council had soon requested that the quarter sessions for those on the outskirts of the borough should be held in Macclesfield and not Knutsford, and a small Cheshire Constabulary office was created in 1837 in King Edward Street. This was somewhere on the old Parsonage House site adjacent to the Dissenting Chapel. It is possible that the building itself could have been adapted for the purpose for a period before demolition took place.

The population of Macclesfield was still expanding, it had been recorded as a little less than 9,000 in the first census of 1801, although this figure, like many others in the count, was probably on the low side. It reached 39,000 by 1851, but by then included parts of Hurdsfield and Sutton; a century later there was remarkably little change.

The Chief Constable

The business of the town council was controlled from its centre of operations i.e. the town hall, and that is where in February 1843 an office for the police superintendent was provided. It was created by partitioning off part of the 'the lower room', a polite way of saying the cellar.

On 1 January of the following year William Harper was appointed Chief Constable to collect and pay over to the council the Borough rates. Many problems had arisen from past rate collections, with one former collector given a prison sentence, therefore it had seemed appropriate for the Chief Constable to be put in charge of such an important job.

As always things did not go according to plan, and on 1 May 1845, a medical certificate for William Harper was read out at a meeting of the town council. It stated that his residence (office) in the town hall was 'unhealthy'! He was most likely rapidly moved 'upstairs' until 1853, when the adjacent 'Guild Hall' public house was bought and converted for use as the police station, including an office for the chief constable.

The drunks could be kept in the town hall cells for the night, but serious crime was on the increase. A decade later Cheshire County Constabulary were pressing for more secure premises

for those awaiting trial in Chester, until transportation could be arranged; the office in King Edward Street was inadequate.

The Cheshire Constabulary

John Brocklehurst Jnr by then MP for Macclesfield, came to the rescue. He, together with four other family members, as trustees on behalf of the chapel, leased 617 square yards of land on the south side of King Edward Street to Charles William Potts of Chester, who was clerk of the peace for Cheshire.

The date of the deed was 26 August 1865 and the premises were leased at a ground rent of £20 per annum 'on trust for the erection of a police station, cells for prisoners, constables' residence (office), and for magistrates' rooms for petty sessions. This suggests that there was still a building on the site; more than likely that created out of the old parsonage building, which was being used as the small Cheshire Constabulary Office.

The ground rent payments are recorded until 1877. By that time, of course, the new police station had been built as an extension of the town hall premises on Churchside.

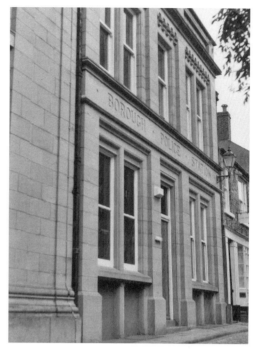

The Macclesfield police station built in 1853 next to the Town Hall to accommodate the Chief Constable and provide new offices and police cells for the Borough.

The building on King Edward Street was substantially built with stone from local quarries, and slates, no doubt from North Wales. It was subsequently used for Cheshire County Council services until its recent refurbishment into apartments. It retains many of the old features (but no longer the cells, although the windows remain in situ at the rear), which have been sympathetically and expertly blended in the new.

The Gas Tar Trial

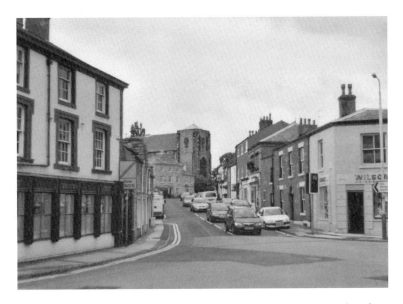

Chester Road, one of the earliest areas in town to have a gas tar road surface.

In 1834, just a few months before the Corporation Reform Act of 1835 came into operation, the Macclesfield Police force found itself involved in the most extraordinary episode – 'the Gas Tar Trial', which therefore took place under the regulations of what became known as 'the Old Corporation'.

Under the provisions of the Police Act a committee was appointed to superintend the making and repairing of the highway within the borough. There were three members, John Hibel, Rowland Gould and George Ainsworth. Hibel in particular was an active character and landlord of the Black-a-moor's Head (to be later known as the Black's head), which was situated near to the Market Place on that part of Mill Street demolished to create Castle Street. In 1849 he would become the only local agent for a progressive Dublin brewing company by the name of Guinness & Co. and would also see the ancient Cockshut Lane brought into the 'modern era' as the thoroughfare Hibel Road.

The people working for the Old Corporation were in effect engaged as self-employed people, and if anything went wrong they were totally accountable and could stand trial.

Hibel, Gould and Ainsworth found themselves in this situation, when the 'upper end of Chestergate' was being repaired.

The trio were summoned to appear in court to answer a charge of creating a nuisance.

The Trial Begins

For several years gas tar had been used in the formation of unpaved roads in various parts of the town, and John Newbold, a surveyor engaged by the committee to superintend the road works on their behalf, was the first to be called to give evidence.

Top end of Chestergate, the area in dispute resulting in the 'Gas Tar Trial'.

They had initially been accused of having 'caused to be thrown down' ashes and other 'filth' contrary to the Police Act. It was stated that this was not the same as that spread on the pavements when the weather was frosty.

Mr Newbold had been a surveyor for several years and confirmed that gas tar had been used on the roads in the borough for the last seven or eight years. He recalled the alterations that were made in Margery Meadow. This meadow has been mentioned in past articles, and had been referred to originally in a medieval deed of 1332. Its exact whereabouts is still unknown, but from later references it was somewhere in the area extending from Lower Chestergate along Chester Road. At last in the nineteenth century it was apparently witnessing development.

Mr Newbold remembered that the gas tar had made a good foundation there, and he had heard of no complaints as to it being a nuisance, nor had anyone been ill from the smell.

He also pointed out that when repairs were made in Sunderland Street, Park Lane, Park Green and the Waters gas tar had also been used, and that he had found it very good for 'binding the stones together'.

Bad Conditions

Chester Road had proved to be very bad, with many complaints about its condition; specifically with regards to it making the incline much worse for the draught horses trying to pull the carts along. In fact, it was so difficult that carts finally could not get along it at all. Mr Gould had sent an order for it to be repaired and Mr Newbold had ordered several carts of tar for the work.

A witness said that his daughter, who was already ill, had been made much worse by the smell. Mr Newbold, who lived nearby, admitted that some members of his family had complained about the smell and one had felt ill, but he was used to it and therefore never noticed it. It was confirmed that in Margery Meadow the gas tar was used only as a foundation and not as a top layer, but in Chester Road there was a good depth of stone so it was put on top.

Mr Thomas, who lived on Chester Road, admitted that the road was much improved but the smell was certainly a nuisance. He and his neighbours had spread three loads of lime on it to kill the smell.

Controversy

Before Mr Newbold continued giving evidence under cross-examination during the 'Gas Tar Trial', Mr Gould presented some information regarding Beech Lane.

When it had been repaired, there had not been enough tar to finish the whole road and none had been used towards the bottom of the hill. The mayor interrupted and remarked that he had heard complaints about the smell from it, but Gould insisted that there was no longer any smell from it, and it was about two years since the work had been completed.

The mayor once more questioned Mr Newbold, asking if the committee had ever ordered him to put gas tar on the road outside the Black-a-moor's Head, which was, of course, Mr Hibel's residence and public house on Mill Street.

The answer was 'No'. The mayor then asked 'It would not be good for spirituous liquors would it?', to which Mr Newbold could only reply, 'I don't know'.

Still not satisfied, the mayor then enquired whether or not it would be proper to use gas tar in Mill Street. Mr Newbold said people were never happy about it at first.

William Saunderson was next called to give evidence. He had been told to lay down the ashes etc. and had worked on the road under the direction of Hibel, Gould and Ainsworth.

On the 16 August he recalled laying a dozen loads of tar on Chestergate, but he was used to the smell and took no notice of it. However when he was questioned further he seemed to contradict himself about the use of the gas tar.

John Hibel

Next it was Mr Hibel's turn to be cross-examined. He had been connected with road making for thirty or forty years and the smell from the gas tar in Sunderland Street would be stronger than that in Chester Road where there was a greater circulation of air, yet no complaints had been received. He argued that gas tar saved a great deal of scraping and only the channels needed clearing. It was an ideal coating for stone.

Samuel Jesper of Beech Lane was next called and described how during dry summer weather 'scent' arising from the gas tar was considerable when the wind blew up the hill, causing black dust to enter the houses. He got used to the smell but his visitors noticed it.

Mr Hibel said that there would always be dust blowing up the hill when the winds were strong.

Many more witnesses were called, including Thomas Wardle, a silk manufacturer who lived on Park Lane. All said the road was better and Wardle insisted that there was 'no annoyance or inconvenience from it'. All agreed that there was a slight smell initially, but that the benefits were greater.

Mr Hibel said that gas tar was being used on a road near Liverpool, and a barrister and commissioner for roads in Manchester had been so impressed by it that he had recommended it for the city.

The mayor, however, then gave his decision, which was that the Macclesfield Commissioners had no right to use gas tar under the Act of Parliament. With that he fined each of the three 20s.

Giving his reason he said that the Act referred to gas and any escape of it and that he considered the smell to be gas escaping; this was liable to a fine of £5 per day. Also there was a clause that read that 'no dust, dirt, dung, offal, rubbish, ashes or other filth' should be laid on roads.

His final words were that 'every facility towards prosecuting an appeal would be given'.

Whether or not an appeal was made is not recorded, but 'here endeth' another saga in the Corporation's history, and another surprising duty performed by our early police commission.

The Hibel Saga

In September 1838, three years after the Corporation Reform Act, John Hibel was once again called to account by the police commissioners. This time everyone was busy creating their own little 'empire' within the Corporation. More population meant more members within the committees, which meant more subcommittees.

The finance committee had asked for the police commissioners' accounts to be produced, as it was the year-end. The police commissioners had asked the highways committee (i.e. Hibel & Co.) to submit their accounts so that they could comply with the finance committee's request. John Hibel had done so, but the wages for the year were written on a slip of paper as £493 5s 2d, with no details given.

John Hibel had previously been asked to submit a wages statement, but had refused because the year had not been completed. Hibel strenuously denied this accusation, saying that the year was completed and he had not refused. Others said the books should be put in the controller's hands and examined each week and it was even suggested that two books should be kept.

Hibel said he had only received the wages book the day before and so the general statement could not be made until the next meeting. He explained that it was John Newton's (the surveyor) book and that Newton accounted for the money at the end of each year. Another member asked, 'then why have you got it?'

Beech Lane leading to Hibel Road – a road particularly discussed in the 'Gas Tar Trial' and later.

Bills Unpaid

A heated discussion arose with one member saying that it seemed as though the highway committee were governors of the town and did just what they liked! The law clerk intervened and said the Act relating to the highways did not recognise any committee whatsoever.

For their part the police commissioners had 'expressed a regret' to the finance committee that some of their bills had been left unpaid for two or three years and asked for a curtailment of expenses in order to pay off their considerable debt of £11,706.

After further discussion, Commissioner Clarke said they had appointed a committee to look after the surveyor and now they were appointing a committee to look after that committee, and he presumed that they would soon appoint another to look after them all!

The law clerk intervened once more to say that the usual course was for the committee to examine the account books and then hand them over to the finance committee at the end of year.

Hibel said he had attended the finance meeting on the last two monthly dates, but as only one member was present each time, it had been postponed. Each time a new date was set he attended but no one was there. He explained that they were allowed £850 each year for improvements, not including salaries and incidental expenses. The police commissioners, during the previous year, had suggested further work on Beech Lane as an afterthought; as the committee had already spent their allowance they had carried forward the £100 to this year's account, making £860 due.

The high constable had threatened them over the state of Buffy Lane and said that they were 'obliged to beg off with tears in their eyes'. Hibel spoke for some time with such passion that several committee members had to hide their smiles. Finally Mr Potts proposed a vote of thanks to the highway committee, 'but especially to John Hibel' who he hoped he would 'persevere and keep his roads good'.

Outcome

Thomas Wardle, the silk manufacturer who had taken part in the discussions, proposed that the highway committee should be voted in for another year. The roads in the township had become more and more efficient each year under their management. He believed that Mr Hibel had given offence to certain individuals, but the charges of lavish expenditure made against him were unfair. It must not be forgotten that many large ratepayers benefited from the Buffy Lane improvements and although it had been little used previously, that was because it could not be used. Mr Wardle had requested improvements there some seven years earlier.

Another member said that there had been a rumour that some of the committee would refuse to continue, but as the chairman pointed out, they were present and none had declined. The vote was carried with only three against.

Alterations to Cockshut Lane were imminent and John Hibel is still remembered by the lane that was renamed Hibel Road. One wonders if anyone objected.

Toll Bars

The toll house fortunately surviving at Lyme Green on the old route to London, south from Macclesfield via Leek, Ashbourne and Derby.

Toll Bar Road indicating the position of the toll bar near Broken Cross on the road leading out of town towards Chelford and Knutsford.

While the roads within Macclesfield borough were the responsibility of the Corporation, those outside were not. The old Roman roads and packhorse trails, which had been used for centuries, were in a deplorable state by the seventeenth century and were the responsibility of the parishes. However, repairs were piecemeal and although the first Turnpike Act had actually been passed in 1663, shortly after the Restoration of the Monarchy, it was not until 1706 that turnpike roads began to be laid down.

With the rapid progress of industrialisation in the eighteenth century, particularly from 1750 onwards, it was an absolute necessity to be able to transport raw materials and goods more efficiently. Between 1760 and 1774 alone 452 road acts were passed and there were 1,600 trusts operating by 1800.

Turnpike Trusts

Trusts were allowed to borrow money for improvements and levy tolls legally by act of parliament. However, it is surprising to discover that many of these roads were in what we would consider today to be some of the most remote areas of England and Wales, but that was because of the importance of mining and quarrying. Goods and raw materials were at first given priority over passengers, apart from the obvious places of interest and pleasure including spa towns such as Bath and Buxton.

In the second half of the eighteenth century Josiah Wedgwood was very much involved in promoting the turnpike road from Leek to Buxton, because of the town's popularity due to its renowned therapeutic reputation. Charles Roe's brass and copper company invested in the London Road leading south to Bosley, where the brass rolling mills were situated.

Initially it was the business communities who had the most to gain from these investments in the form of shares, however, local communities in general also began to appreciate the benefits, although many individuals would 'suffer' along the way!

Trustees for each trust were selected together with a clerk, who was usually a local solicitor who could attend to legal matters.

William Brocklehurst, a solicitor and member of the famous Macclesfield silk family, in 1827 became clerk to the Trustees relating to that part of the road, running from Sandon in Staffordshire to Bullock Smithy (now Hazel Grove) Cheshire, which related to the Macclesfield district. Annual general meetings were held, and when necessary adverts appeared in the local newspaper, the *Macclesfield Courier*, when a particular turnpike trust had shares available for investment.

Locations

Tolls were paid on certain vehicles, and toll bars placed at certain distances along the roads, together with unusual shaped houses for the toll keeper. Very few are now left standing, but the one at Lyme Green has fortunately survived, as pictured in the photo.

Just before Broken Cross (on the Chester Road out of town) there is Toll Bar Road, again indicative of where another tollgate and house were situated. A plan relating to the estate of John Ryle clearly indicates the position of the one on Congleton Road, which was situated on the area until recently occupied by a derelict petrol station.

The site has now been grassed over excellently and a path provided for residents to a new set of traffic lights. This is, of course, between Moss Lane and Congleton Road and forms a shape similar to an arrowhead.

The Toll Bar

The toll bar was actually a large gate that stretched across the road and was kept locked, until the toll collection had taken the dues and let the vehicle or riding traveller through. The only instance where he opened the gate in advance was when the red mail coach, with its immaculately scarlet dressed officers, charged along the road and sounded the post horn. The collector knew almost

to the minute when to expect it each day, and then he would dash out and open up the gate, to see the express delivery charge along the road, in the Maclesfield area it was usually to and from Manchester via Stockport.

We are so used to accidents from speeding in our modern world, that we tend to forget it had been a matter of great concern for centuries; even Roman chariots could cause havoc and so too did turnpike roads.

Hibbert's Coaches

As the surfaces of turnpike roads improved, so speeding increased. Hibbert's was an important Macclesfield coach company operating from the Chestergate coach office.

By the 1820s they had six coach routes operating each week to Birmingham, Liverpool, Chester, Nottingham, London and Manchester.

Manchester was the only route which had two coaches departing each day at 3.30 p.m. and 5.00 p.m. On 4 December 1822 one of their coaches, the *True Briton*, was returning from there and had reached the road approaching Bullock's Smithy (Hazel Grove) when a rival coach of Messrs Whittaker tried to overtake.

The Whittaker's driver tried in vain to pass, but Hibbert's coachman would not let him through on the inside. With another attempt the two coaches charged along neck and neck for some distance, when suddenly Whittaker's coach went over.

Several passengers were hurt including the mayor of Macclesfield, Thomas Ward. One passenger said he did not want a broken neck because of the rivalry between coachmen and they all agreed to sue the driver and proprietor of Whittaker's.

Accidents

When accidents occurred they could be nasty; like the two young men who decided to have a race while returning on horseback from Leek market in high spirits. On rounding a bend one rode straight into a gig returning from Macclesfield. The shafts of the gig acted like lances, impaling the young man impaled and causing the horse to suffer terribly!

In November 1840 Macclesfield newsreaders were shocked to learn of an accident involving the famous poet Wordsworth. He and his son, Revd John, were returning home to Rydal Mount from a visit to the Earl of Lonsdale at Whitehaven Castle. They were in a one-horse gig and were about 3 miles from Keswick at Ruffa Bridge on the Ambleside Road.

There a sharp bend at the top of an incline that led down to the bridge gave them little time to see the mail coach 'rattling along'. They had reached a narrow part of the road, but Revd John immediately drew the gig into the side of the road. Normally there would have been room for the coach to pass, but the off-side horse (used to holding the bridle bit in his mouth) refused to obey the reign of the mail coach driver.

The coach struck the gig violently and crashed it through the wall, taking with it the horse and the Wordsworths.

Fortunately the impact broke the traces and shafts near to the body of the gig, and the poor terrified horse managed to regain its feet. It immediately jumped over the broken wall and set off at a 'frightful pace' with the gig shafts still attached to the harness.

It dashed for 9 miles and many attempts were made to stop it while en route, but all failed. At last the toll-bar keeper near Grasmere saw it coming and made sure the gate was closed, although he was frightened that the horse would try to jump the gate. The exhausted horse finally came to a halt.

The only injury to the poet was a slight scratch on his finger, otherwise he and his son were unscathed. What happened to the driver and the mail coach goes unreported.

Even pedestrians were not safe; in two separate incidents two elderly ladies, who did not hear wagons approaching from behind, were shouted at by the drivers to get out of the way. Both, being startled and confused, on turning round dashed in the wrong direction and were run over by the wheels of the carts; neither survived.

And, if accidents were just as horrendous as today, legislation was no better. In fact, the toll keeper had quite an important job to do and it was one which did not get any easier.

Legislation

Apart from the tollgates already mentioned on roads leading out of Macclesfield to the west and south, there were also gates at Tytherington and Butley leading north and on the Hurdsfield and Buxton roads on the east; surprisingly, the latter was much later than the others.

The new Buxton Road was created during 1822–23, and branched off, as today, just below Shakespeare House (see *Past Times vo. II* page 210); it was there that the turnpike was established.

In December of the same year the public was informed of the government's intention to 'tidy up' the previous turnpike legislation with the passing of the General Turnpike Act. This repealed all the previous sixteen acts, but encompassed a considerable amount of legislation to be implemented from the 1 January 1823; it was also extended to all local acts.

This was to bring about a uniform system throughout the country and, therefore, the Macclesfield Corporation had to make sure that the conditions required for road usage outside the borough, were also met within the borough.

The poor toll-bar keepers bore the brunt of it and had to carry out their duties for checking the different types of vehicles (and there were many) and road users (e.g. people on horseback, pedestrians pushing hand carts or animals being herded along) and charge according to the new tariffs and penalties as necessary.

Among the regulations were such things as the size of wheels, the different lengths of axles and nails (which had to not protrude more than a quarter inch from the surface of the wheel).

Tolls were stipulated for those overweight. This category included carriages carrying one log or tree, one block of stone or cable, but did not include carts of manure, hay, straw, fodder or corn 'unthrashed'; those carrying hay, straw, fodder or corn for sale were also exempt. Two draught oxen or horses, having passed through the gate and returned drawing a carriage, were to be charged the

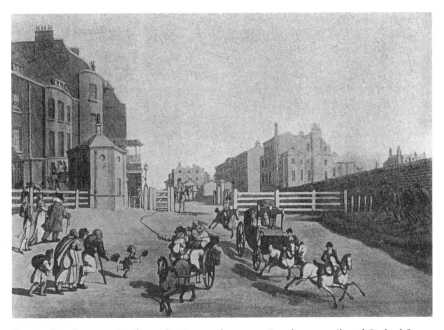

'Don't all rush at once' – the early nineteenth-century London turnpike of Oxford Street or Tyburn.

difference only between the first toll paid and that now due. Horses with carriages were allowed to return within eight hours, even if the time of return was the next day i.e. after midnight.

There were different rates for carriages attached to one another, carrying goods (with or without carrying passengers); the list seemed endless. We moan about traffic queues today, but imagine trying to get through a final turnpike into a large town or city on market day. One can well feel sympathy with the toll keeper, having to exact a toll in the middle of the night in mid-winter; then, no doubt, his many checks were completely ignored.

Exemptions

The list of exemptions was just as long, and probably caused many arguments. Royal carriages were exempt, together with carts carrying materials for road making or repairs; surveyors of the roads who were on duty were also exempt, along with horses and cattle going to or coming from ploughing, pasture, water, shoeing or the farrier.

It included those vehicles carrying prisoners, mail, ordnance, public stores, horses or soldiers on the march or on duty, yeomanry and equipment, people travelling to and from elections or not travelling more than 100 yards along the road, and those going to and from funerals in the parish where the church was, or going to church.

Problems

There had been a dispute with a Methodist minister on the Staffordshire border, who had to ride to different parts of his circuit every Sunday. The matter eventually was resolved, as the minister's persistent claim that Methodist ministers on duty were exempt, was proved to be correct.

No one was to build a wall or fence and such like within a certain distance of the centre of the road, nor have a gate or door opening outwards onto the road. Any stray animals such as donkeys, sheep or swine on the road could be impounded and the owner charged 5s. Anyone refusing to pay a toll in charge of a vehicle could have the vehicle, horse etc. seized and sold.

Many years ago a quote on a business calendar read 'the Romans came to Britain and built the roads straight: we English arrived and made them all crooked'.

Toll Bar Anomalies

The response from readers in respect of the information about the Macclesfield toll bars was surprising, and revealed just how interested they were; however, one query in particular needed an explanation. Aware of an anomaly in relation to the Buxton Road turnpike, it was a chance remark by one of my local history enthusiasts, Mark, and provision of maps by another, Philip, which seems to have revealed the answer.

The question arose about the Buxton Road turnpike on the eastern side of the town, which should have been set up just below the Shakespeare Inn (now Shakespeare House) where the new and old roads from Buxton converge. It is shown there in the *Historical Atlas of Cheshire*, but later maps from 1838 clearly show it to be situated further down Buxton Road, above the canal bridge between Black Road and Barracks Lane. There is, of course, the Toll Bar Avenue in that area just off Black Road.

The new turnpike road was begun in 1821 and completed 23 July 1823. The man in charge of the overall construction was one of the famous Mr McAdam's engineers and a surveyor by the name of Pearson. Several hundred men had begun the section comprising the One House to Walker Barn during the first week, and at the same time a team started at the Buxton end of the section.

When completed it was carefully examined by 'chief officials' and declared fit for traffic; however, all was not well. A report claimed that the work was so badly done, in what appears to be a fairly short period of time, there was no alternative but to dig up the road and set about re-laying it. The cost proved astronomical. Instead of the original cost of £2,000 the final result was £12,000, which had to be paid for through tolls!

The area of Buxton Road where the old and newer Buxton roads converge, as indicated by the van, and where the original turnpike was intended to be placed.

It was not until 1852 that the original Buxton Road Act came up for renewal, at which point the full story began to emerge because of opposition from many Macclesfield inhabitants. By this time the sum outstanding had reached £23,000 including interest, and they elected a Mr Smythers to be their spokesman.

Evidence

Smythers pointed out to the parliamentary committee that two gates were actually inside the borough boundaries, one on the west near Broken Cross and the other on the east on Buxton Road. This was a direct contravention of clause thirty in the Towns Amendment Act, which prohibited any tolls being taken within the limits of a borough, and many more people were living just beyond the toll gates as the town had expanded. This should never have been allowed originally and they wanted the gates removing.

The trustees had had difficulties letting the Buxton Road tolls and had no alternative but to collect them themselves, under the circumstances they would not consent to a reduction of income by a third. The annual income from Broken Cross was £190 a year and from Black Road £80 a year. They calculated that this would clear the debt in twenty-one years, but if removed it would never be paid off. This seems to indicate that the road had been re-laid around 1830–32.

Among the creditors were several charities which had invested money in the road.

The chairman of the committee said there had to be a compromise, and the bill was finally passed in May 1852 with a four year limit before the gates were to be removed. This would mean that only two tolls would be payable through Macclesfield all the way to Buxton instead of four.

It would seem that the decision to set up the toll bar lower down Buxton Road, and the one at Broken Cross, had been contrived to collect additional tolls after the disastrous road fiasco and that the original tollgate had been higher up the hill.

McAdam

Interestingly, McAdam himself had appeared before a commons committee in April 1825. On that occasion he was asked what the best materials for roads were, and the cheapest method of obtaining them. Answer: Berkshire flints for roads further from London, but Guernsey stone was best and least liable to wear.

When questioned as to why some of his road surfaces were breaking up, he explained that drainage was 'too much neglected' in town and country. The principle was to keep the soil dry and tight, if subsoil was dry from above and below then the road would not give way. He went into the greatest detail of building up the surface, declaring that the consideration should be the subsoil and not the carrying of carriages on the surface, an idea he found difficult 'to drive into the heads of the surveyors and to compel them to attend to!'

Evidently this is the answer regarding the deterioration of the original Macclesfield to Buxton turnpike road surface.

On this triangular piece of land at Tytherington once stood a turnpike; the old route originally followed Bluebell Lane.

Old Mill Lane

A further query from my correspondent was the question of when the turnpike road from Higginbotham Green via Lyme Green was laid. The only information I have is a copy of a deed for a property on Old Mill Lane when the plot of land, part of the Mill Field, was sold for building upon on 14 February 1815. The boundary description given states 'on the Eastwardly end thereof by the Turnpike Road leading from Macclesfield to Leek' (now Old Mill Lane); the present Crosse Street was still a plot of land.

Presumably this section of the Turnpike Road linked into Byrons Lane and passed through Sutton on the older routes out of Macclesfield south. Possibly, with the creation of the better road through Crosse Street, the new section of the turnpike road was created along the route which now passes the Fool's Nook; this must have been after 1815.

An old photograph of the site of the toll bar in Tytherington.

Tytherington

The Tytherington turnpike was at the junction of Manchester Road and Bluebell Lane, the old route followed the lane round and came out further down the hill. When the new section, which extended Beech Lane, was created it actually passed through the land of the Tytherington Hall estate.

In drawing to a close the information on the Macclesfield and district turnpikes, what better way than to quote the words of Charles Dickens through some of his delightful characters in *The Pickwick Papers*.

Having arrived at the Mile End turnpike when leaving London, the coach driver Sam Weller senior, turned to Mr Pickwick and said 'Wery queer life is a pike-keeper's, sir.' 'A what?' asked Pickwick. His son, Sam junior, who was also Mr Pickwick's servant, explained that his father meant a turnpike keeper.

'They're all on 'em men as has met with some disappointment in life,' said Mr Weller senior. 'Ay, ay?' said Mr Pickwick.

'Yes. Consequence of vich, they retires from the world, and shuts themselves up in pikes: partly with the view of being solitary, and partly to rewenge themselves on mankind, by takin' tolls'.

'Dear me,' said Mr Pickwick, 'I never knew that before'.

Queen Victoria's Accession

In June 2007 it was 170 years since Queen Victoria ascended the throne. Her uncle William IV died on the 20 June, and although his reign had only lasted from 1730 to 1737, yet it was one of the most significant in modern British history.

He was the third son of George III, born in August 1765, and at the age of 14 years had entered the navy as a midshipman on board the *Prince George*. The ship, which carried ninety-eight guns, was part of the Channel fleet and upon it William saw much action, particularly against the Spanish in 1781. Subsequently the ship joined the fleet sent to relieve Gibraltar and then saw further action off the American coast.

Soon William was transferred to the *Barfleur* under the command of Admiral Lord Hood, and there he met Horatio Nelson.

By 1785 he had passed his midshipman's exam, and the following year was appointed first lieutenant on the *Pegasus*. The captains, who were at that time in Plymouth, asked that they might be introduced to him, and William agreed a time for the next day. When the meeting took place he 'expressed surprise' that none of his fellow lieutenants were there and insisted on seeing them the following day.

William Brocklehurst, mayor when Queen Victoria ascended the throne on 20 June 1837.

Soon he came under the command of Nelson and would later recall, 'It was at this era that I particularly observed the greatness of Nelson's superior mind'. They became great friends and corresponded until Lord Nelson's death.

By promotion William moved up in the ranks to become Admiral of the Red and finally, in 1811, Admiral of the Fleet. He narrowly escaped death in the attack on Antwerp in 1813 when he received a shot through his coat and the musket ball took the hilt off his sword.

After his death in 1837 he was greatly mourned, and his reign is best remembered for his attention to the navy, in particular appreciating the importance of the Falkland Islands and Gibraltar, and for the first bold step taken in the reform of parliament. This had given Macclesfield the opportunity to elect two MPs to the House of Commons, one of whom was John Brocklehurst of the important silk family.

It happened that John's elder brother William, who was a partner in a firm of solicitors on King Edward Street, was mayor for that year of 1836–37, when the proclamation of Queen Victoria took place.

The under sheriff of Cheshire, J. Roscoe, had been busy throughout the week with his proclamations in different towns, and finally arrived in Macclesfield on Thursday 29 June at 4.00 p.m. in the afternoon. He was met by a procession in company with the Cheshire Yeomanry

and three societies, one of which was the Freemasons. Two bands took their places in the parade, and were joined by hundreds of 'respectable' inhabitants.

They left the town hall and marched down Mill Street to Mr Corbishley's factory on Park Green, where the Proclamation was first read, and then on through Sutton to Mill Green.

After the ceremony in Mill Green the same was repeated in Waters Green, the procession having walked along Sunderland Street; yet again in Commercial Road in Hurdsfield. Having returned to the Market Place via Jordangate, it was the turn of Mayor William Brocklehurst, standing on the town hall steps, to read the proclamation for the final time.

He then thanked the considerable crowd for their attendance, expressing the sentiment that he expected no less from the loyal town of Macclesfield.

The mayor, accompanied by the under sheriff, magistrates and Corporation, and the two captains of the Yeomanry, Antrobus and Ryle, along with a number of 'gentlemen who had joined in the cavalcade', then retired into the town hall to drink the health of Her Majesty. A number of them remained for some time 'to enjoy the mayor's hospitality'.

Duke Street School

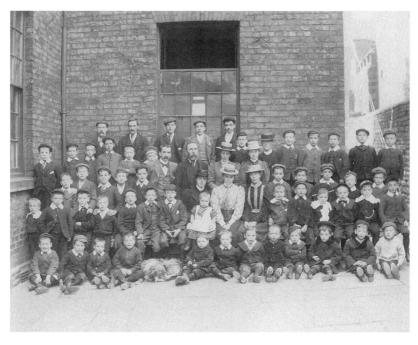

The boys' department at the National School, in all probability taken in 1913 to commemorate the centenary of its existence.

Thanks to a suggestion by a great Maxonian character, Geoffrey Hunter, it seems that the question of the mysterious Edwardian photograph that I had inserted in the paper for identification has at last been resolved. He suggested it could be the National School on Duke Street, and research has proved him correct.

A Georgian engraving of the school has identical windows in the upper storey at the front, and along the rest of the building i.e. the number of panes are the same. These were subsequently replaced with twentieth-century ones, which appear on a photo of the derelict building shortly before demolition in the mid-1960s, when the Duke Street car park was created. By then the building was in an appalling condition.

Another informant remembered seeing a 1901 photo of the girls' school and brought it along for comparison; this, however, was taken outside the front door of the school.

From a small plan, reproduced here, it can be seen that there was a corner to the building on the girls' side, with a wall running alongside. This wall was of stone, although the school was of brick, and is identical in both my photograph and the 1813 engraving.

The photo of the boys must have been taken around 1913; this proved to be an eventful year and not only because it was the centenary of the building. A trawl through the newspapers for that year, has unfortunately failed to identify the specific event, however, it did bring to light one or two very interesting items.

The school was, in fact, the Parochial Church School often referred to as 'The Old Church Schools' because both the boys and girls were under one roof, and since its earliest days it had not only been a Day School but also the parochial Sunday school. In other words it was the school affiliated to St Michael's, which became the parish church only in 1835.

Events

From the various reports of the period it would seem that the school was the hub of a large community, where musical evenings and concerts were organised whenever possible, with the pupils of the Day School sitting an examination each December.

An Easter event, in aid of the school, was held there on 26 March 1913. About 200 people were present, all enjoying an excellent tea provided by the vicar Revd Dr Coade, vicar of the parish church, and the Sunday school teachers. This was followed by a musical evening with songs, recitals, recitations by Miss Eileen Coade, piano solos by Miss L. Anderton ALCM and a reading by Mr C. Seal, Bachelor of Music, Oxford.

Three other ladies and gentlemen made up a singing group and it is possible that some of the entertainers appeared on the photographs as possible teachers. The minister on the back row with the boys' group would appear to be Revd Coade.

The following January there was a tea party and concert, which at that time of year included a prize distribution, but in between these two events some very important steps had been taken.

Education Act

In 1896 it was proposed to carry out a considerable restoration of St Michael's, at an estimated cost of more than £13,000. After two years donations totalled £10,000 and the considerable work was undertaken and completed in 1901. After the huge fund raising effort the school appears to have been somewhat neglected, but by 1913 a new Education Act demanding tighter rules and regulations meant that unless something was done the school would be forced to close. Revd Coade was having none of it and started a forceful campaign to save the school.

It was later reported that the school improvements had been carried out at great cost and a 'heavy burden' had been placed on the shoulders of the vicar and some of his parishioners, all of whom had come forward to stand surety for a large loan so that the work required would not be delayed. They had trusted in the fact that when the appeal to the 'Churchpeople' of Macclesfield was made 'they would respond'.

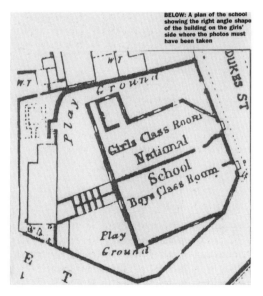

BELOW: A plan of the school showing the right angle shape of the building on the girls' side where the photos must have been taken

A plan of the school showing the right angle shape of the building on the girls' side where the photograph must have been taken because of the position of the single window, and also the absence of a door.

The Great Bazaar

While the National School's Easter event of 1913 had been successful, there still remained a sum of little less than £2,000 required to clear the debt for the restoration. Another superb

effort began resulting in 'The Great Bazaar' of 22 November 1913, held in the Drill Hall, and continuing for four days.

So significant was this that Lady Grosvenor, who was opening the bazaar and accompanied by Lord Grosvenor, had travelled all the previous night from London to be there. She had had an important prior engagement that could not be put off, when the chairman announced this to the people and VIPs in the crowded hall, there was 'great applause'.

Miss Agnes Christa, a well-known singer, came especially for the occasion; she sang an Edward German piece and was presented with a lovely bouquet by Miss Coade. Lady Grosvenor was similarly rewarded.

The stalls were full of beautiful things and so great was the response that over £2,000 was collected in total. When the announcement was made at midnight on the Saturday evening, which would of course free the school from debt, 'it was cheered to the echo' as were many individual workers.

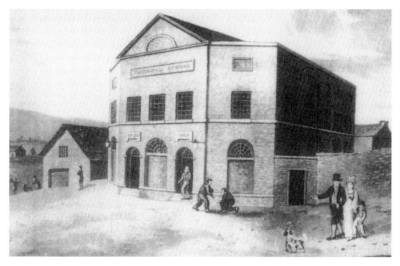

Early nineneenth-century engraving of the National School on Duke Street. Note the King Charles spaniel in the right foreground, a very popular breed at that time.

Evening School

The school then also took on the role of a domestic and evening school under the auspices of the Higher Education Committee. It appears to have been very successful as one of Macclesfield's 'Continuation' schools, with surprisingly varied courses. In November 1913 several Duke Street girls were successful in the Lancashire and Cheshire examination under the categories of human physiology, domestic economy, dressmaking, millinery, home nursing and, of course, cookery.

I have previously remarked that when a building is demolished its existence is sadly soon forgotten, as appears to have happened in this case. It remains now to see why it was established in the first place.

History

The Macclesfield Sunday school had actually been instituted on 1 May 1796 when a group of ministers of all religions in the town had met to establish a school for working children. One of the aims was to educate them with good religious principles from which they could learn to be better individuals. The other was to encourage them to read and write. By learning to read they could then read bible stories etc. for themselves.

A former minister of St Michael's, while he approved the lessons in reading, was not so happy about the writing and further education. In effect his argument was much the same as today; that children and young people were being educated for jobs that did not exist. He felt they would become discontented when, thinking themselves better than others, they would be denied better jobs than, for example, those labouring all day in the silk mills.

The movement, however, went ahead, and one of the principle enthusiasts was Revd David Simpson of Christ Church. The classes were held in various places around the town including factories. It was originally agreed that the movement would be nondenominational, but inevitably schisms began to appear.

Simpson died in 1799 and a Methodist by the name of John Whittaker became a strong promoter for the idea of one large Sunday school in one building. Incidentally it was one of his daughters, Mary, who married Charles Roe's son Joseph, who had become a devout Methodist, much to his father's chagrin. Unfortunately Whittaker's 'takeover' was not appreciated outside Methodist circles, and the Church of England decided to establish their own school, the National School.

Masters

Both schools were built at almost the same time, with the Roe Street Sunday School just ahead of its near neighbour. The national school soon achieved state aid, after which John Braithwaite became headmaster, but left in 1835 to become teacher of arithmetic at the grammar school. The next headmaster, Mr Millett was provided with a house and received £70 per year if he agreed also to superintend the Sunday school.

In 1840 George Peachey became master and only resigned in 1898 due to ill health. He was strict on truancy and discipline and earned the nickname of 'Black George' by the boys, although in somewhat affectionate terms because he was deeply revered by all. During this time there was even an 'upper crust' academy for young men in the building.

It is difficult to believe that while very few schools have withstood the rigours of time, many others in the town have since disappeared, and are still doing so.

Victorian Christmases

A fine specimen from a herd of Highland cattle grazing in a field near Macclesfield.

In the early years of its existence, the editor of the local newspaper had great difficulty in reporting something both local and seasonal for Christmas, and usually found himself drifting off to some other part of the known world where we English always had something interesting to report.

It wasn't until the spring of 1840 that Macclesfield readers learnt of an extraordinary event, which had taken place the previous December on one of the Falkland Islands.

A Mr McKinnon was on duty there in 1839 and recorded the story.

The Falklands

The British Government had legally laid claim to the islands after a complicated history involving France, Spain and even America. A small military force had been sent before the first British settlers could follow and, having no fresh provisions for quite some time with Christmas approaching, the company lookouts saw a fine herd of cattle on the peninsula; their Christmas dinner was beckoning.

Mr Sullivan, commander of the naval vessel, his brother and Mr McKinnon, together with five other crew members, decided to capture one of the animals. They took to the boat with guns and a dog called La Porte. When they reached the shore about twelve of the bulls tore over to greet them, but then, sensing that a hunting party had arrived, started a stampede in the other direction.

The Herd

Knowing of an inlet further along the coast and a pass about two miles inland where they could cut off the herd, the company quickly repositioned themselves. By this time the vanguard of bulls

had slowed down, but, trotting up first, got wind of the men. The animals stopped, bellowed loudly, and tore up the ground with their horns. By then it was nearly dark as the main body of the herd, comprising fifty cows, heifers and calves arrived. 'With a loud cheer, in a line, we advanced', wrote McKinnon.

Alarmed, the cows and calves fled back towards the peninsula. The bulls retreated slowly but surely, then suddenly turned tail causing everyone to rush forward full of excitement, each wondering 'who would have the honour of putting the first ball in our Christmas dinner'.

As the men rushed up an incline at great speed, McKinnon caught his foot on a stone and was thrown down a steep gulley. Having sprained his ankle in the process, he was also knocked senseless for a few minutes by hitting his head on another stone.

He had been next to last in the forward dash and the last man fell over him, but, realising what had happened, stayed to help.

Fright

Bounding quickly ahead, the dog seized a calf by its nose and Mr Sullivan managed to grab it round the neck, but was dragged some distance before one of the crew managed to secure it with rope. Its infuriated mother charged; she was hit by bullets several times and fell. Mr Sullivan, thinking her dead, walked over, but she was instantly on her feet and charged again. The commander kept a cool head and when she was within five yards, having his double-barrelled shotgun ready, he shot her straight between the eyes.

Still the sturdy beast came on furiously, knocked the gun out of his hand and struck his chest with her head; fortunately for him the horns arrived on either side of his body and actually tore up the ground on both sides. As she passed over he was trampled by her hind hoofs and would have been killed without the swift action of his brother. As the cow turned to charge again, the brother put his musket within a foot of her body 'and almost blew her heart to pieces'.

As the crew, already shaken and exhausted, made their way back towards the boat, the main herd turned and started an attack. McKinnon, who was hobbling along with help from his companion, saw it was too late even to run if he could, so the pair lay down in fright; 'on they came, all mixed together, plunging and bellowing, passing, like a whirlwind within ten feet of our concealment'.

They had never been so frightened in their lives, but eventually made it back to the ship, all in a state of shock. There they met a landing party setting out to search for them as it was nearly midnight. Here the account ends, and no mention is made of whether or not they were able to enjoy their Christmas dinner.

Settlement

The British Government, wishing to establish a permanent settlement in the Falklands, used the early months of 1840 to advertise the proposed new colony through the efforts of the Colonial Office.

At this time England was going through one of its periods of depression, particularly in the farming communities, and as a consequence there were many volunteers for the South Atlantic adventure.

The first group arrived just in time to spend Christmas there, followed by the New Year of 1841. They had sailed with Mr J. B. Whitaker on the *Susan*, described as a beautiful big ship of 200 tons. Also on board were a fine number of 'long-woolled sheep', pigs and poultry, 'superior' dogs and stores.

The settlers built a large house while they waited for a second vessel, carrying more migrants and stores, to arrive from London. In command was Lieutenant Tyssen who made great improvements and spoke well of their efforts, including a group of 'Scotchmen' who were to help Mr Whitington with whaling and sealing.

They captured and tamed about fifty horses, but needed some good English stallions to improve the breed. Many hundreds of horned cattle had actually also been caught, which were supplied to passing ships for one and a half pence per pound – apparently with greater expertise than that used in the previous year's fiasco!

American Privateers

Unfortunately the lieutenant had no power to prevent the 'lawless conduct of the Americans'. These were American privateers who had remained on the islands after the American War of Independence, during which the British navy had been fully occupied elsewhere.

On 15 December 1840 Captain Roxby had arrived in the 'Essex' at Port Louis, a splendid harbour, and took on board water, fresh beef, vegetables, fuel, wild rabbits, geese, ducks, and fish etc., which were plentiful. He carried back the information about the settlement.

By coincidence the 'Noble Colonial Secretary' at this time was none other than Lord Edward Stanley, son of the 13th Earl of Derby, whose family connections with Macclesfield are centuries old.

His London home was a mansion in St James's Square, but in the New Year of 1842 something unusual happened at his office.

New Year Gift

A New Year's gift, which was actually a Christmas present delivered late, was left at the Colonial Office in Downing Street by a man who said it was a 'costly' chandelier. He asked for Lord Stanley, but was told that both he and Lady Stanley were visiting Queen Victoria at Windsor.

The man then produced a Customs House certificate, declared the gift to be from a foreign court, with thirty-five cases of wine to follow, and reclaimed the duty of £3 5s 4d – a not inconsiderable sum. By the time Lord and Lady Stanley returned to the square the present was waiting. On carefully opening it they discovered cheap bits of bric-a-brac which had been packed

Advertisement from *The Illustrated London News*, 1891.

well to stop them rattling around inside the case. Shortly afterwards the culprit was traced and apprehended by the police.

Baron Stanley

Meanwhile, residents in Macclesfield were also reading about his distant cousin Sir John Stanley, who had recently been created Baron Stanley of Alderley. While out shooting on a visit to his brother William at Hooton on the Wirrall early in December, the percussion cap on Sir John's gun flew off, lacerated his lip and knocked out two of his front teeth. He hurried to London for advice and would have found it difficult to enjoy either his Christmas or New Year celebrations.

Another newspaper item of the New Year explained the custom of Christmas boxes. It was first begun centuries before by sailors on ships. A box was nailed to the mast on going to sea, and at the time of storms or great danger a coin was put in it and prayers offered. When the ship returned safely, the money was donated to the church or chapel at Christmas time, and was usually received at the entrance to the church or chapel.

Prestbury Accident

The River Bollin at Prestbury, close to where the drama was played out in March 1823.

In March 1823 a report headed 'Providential Escape at Prestbury' retold the details of Friday 19 March 1823. A little boy of only four years of age, and son of a Mr Pattenson, was sitting on a wall that adjoined a wear alongside the River Bollin in Prestbury. There was a paddle in the wall, which was placed at the opening of a watercourse supplying Mr Swanwick's factory.

The watercourse was covered in for about 100 yards, as it passed under the road before it reached the paddle.

As soon as the child fell into the water Mr Pattenson rushed to save him and leapt into the river, but unfortunately the boy seemed to have disappeared under the paddle. As the child 'glided' under the water Mr Pattenson at first thought that he had managed to grab one of his son's legs, but his attempt was all in vain. Because of the force of the water, he too would have suffered the same fate as the boy, had it not been for a workman busy nearby.

Thomas Hooley did not hesitate to go to the rescue and dragged Mr Pattenson, quite exhausted, out of the river. It was difficult to get under the paddle without completely going under the water, but Hooley, presumably the stronger man and encouraged by the father, was about to dive in when the vicar of Prestbury, Revd J. R. Browne, came along. Learning quickly what had happened he sprang into the water and discovered that the child was not caught under the paddle.

Then the vicar took immediate action to have the paddle closed and gave instructions for the one below the wear to be raised so that the watercourse would empty. The rush of water was considerable, but there must have been consternation when nobody appeared. The only option then was for the tunnel to be explored.

Rescue

By then word of the tragedy must have spread, and 'two hardy fellows', John Wheelton and Thomas Dunbar, took up the challenge. As most of the water had gone from the tunnel they pushed themselves along for quite a distance. The only way they could manoeuvre was on their backs, and this they did through the muddy sludge and remaining puddles, hardly able to breathe at times.

Suddenly they both heard the faint wailing of a child, which inspired them to make a great effort, despite the fact that both were extremely weary by this time. There, about three or four yards from the upper paddle, among a tangled mass of sticks and rubbish, was the little boy.

Fortunately he had actually been forced into a standing position by the strong force of the water and the mass of rubbish, and this had kept his head out of the current for quite some time. Being small the paddle was just high enough to have allowed him to stand upright.

One of the men managed to lift him onto his chest, and all three had to return feet first down the whole length of the tunnel as there was no room to escape at that end. As they came out the boy was lifted to safety from the totally exhausted man.

The vicar again took charge and told the rescuer from the bank not to hold the child up by his heels for too long as he might suffocate.

An anxious time followed, and for five hours the boy's 'jaw was locked' and his pulse and breathing were almost gone. But quite suddenly he came to and soon seemed to have recovered, despite the fact that his ordeal in the tunnel had lasted almost three quarters of an hour.

It had indeed been a 'providential escape'; many others who fell into rivers were not so lucky, and did not live to tell the tale.

Leap Year

The morn of St Valentine. Engraving from *The Illustrated London News*, 1881.

The year 2008 was a leap year, but what history or mystery lies behind 14 and 29 February and why should a woman be traditionally able to ignore convention and propose to a man of her choice?

The Valentine tradition has been written about on numerous occasions, yet no one really knows who St Valentine was. Two particular saints called Valentine are listed as Roman martyrs on the 14th, both of which have inspired many legends. The most logical explanation seems to be that, at least from Chaucer's day, birds were said to pair on 14 February. This being celebrated in the church's calendar as St Valentine's Day, created the connection with love, romance and the expression 'a pair of love birds'.

A unique and formidable collection of correspondence, known as the Paston Family letters, written between 1422 and 1509 are the earliest known collection to have survived in Britain and do mention the act of being a Valentine. The family lived in Norfolk and wrote copiously to one another, friends and associates, so the letters are an invaluable source for information of that time.

Leap years, of course, have a scientific basis, but this does not answer the question of why women can offer marriage to their desired suitor. The extra day allotted to February helps to adjust our calendar – known as the Gregorian calendar because it was introduced by Pope Gregory Xlll in 1582 – although not corrected in England until 1752.

A leap year calendar had already existed in Egypt from the time of Ptolemy III in 238 BC They had studied the heavens and realised the sun's rising and setting did not keep to an exact time schedule.

Adjustments

Today modern astronomers can calculate and make adjustments in a more precise way. This means that corrections are necessary from time to time, i.e. if a year is divisible by 100 it is not a leap year (but not if divisible by 400). The last was in 1900, which reminds me of a colleague many years ago telling me that when her father was a small boy he had to wait eight years for a 'legitimate' birthday, as he had been born on 29 February 1896.

The first occurrence of this missed leap year was in 1800, and would have affected the famous composer Rossini in the same way. Born on 29 February 1792, from the age of four he would have had to wait until he was twelve years old to celebrate his birthday on the correct date.

Rossini

A very interesting Italian news item was brought to the attention of Macclesfield readers on 5 November 1842, and reveals something of Rossini's love and passion.

It stated that Rossini had placed in the hands of a notary (a person legally authorised to draw up documents) in Bologne, France, a sealed packet that could only be opened after his death. The packet was addressed to 'Madamoiselle Olympe P—' and was supposed to contain an opera; this the maestro had willed, together with his fortune, to the lady. She had been his companion for quite some time.

Gioachino Antonio Rossini had been born in Pésaro in Italy, just south of Rimini on the Adriatic Coast, where his mother and father, although of musical, but moderate, means, had encouraged his early musical talent. He learnt to play the harpsichord, then pianoforte, had singing lessons and subsequently graduated to the cello.

His first opera was produced in Venice in 1810, with his most famous *The Barber of Seville*, performed in Rome on 20 February 1815. Between 1815 and 1823 he wrote twenty operas, then arrived in England on a five months tumultuous and lucrative visit before becoming a musical director in Paris. His last opera was 'William Tell' in 1829.

So what was the opera, if any, in the package? And who was the mademoiselle?

In 1822 Rossini had married Isabella Colbran, a coloratura soprano. She died in 1845, and on 16 August 1846 he married Olympe Pélissier, obviously the companion not quite named in 1842. Rossini had semi-retired by the age of thirty-two, having acquired a considerable fortune. From 1832 until his death in 1868 there were periods when he was considered something of a recluse, yet he enjoyed intermittent periods of '*joie de vie*'.

His first marriage could not have been a happy one, and perhaps fears about his own health had caused his gesture to Olympe in 1842, with whom he had shared his passions for some time. She had possibly finally encouraged him to 'tie the knot' (although it wasn't a leap year) but was the package then retrieved?

Balloon Flights

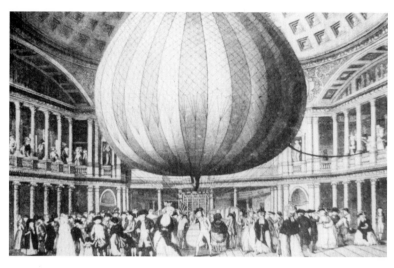

Lunardi's balloon on show in the Pantheon in London; on another occasion, it appeared in the Lyceum theatre with the 'balloon spotters' always in great support.

On the first of June 1826 people living and working on the Staffordshire and Cheshire border were 'annoyed and dismayed' to see one of those 'huge machines' – a large balloon – approaching. It descended near Swythamley Park, and some labourers seeing it unoccupied, managed to secure it.

There is no doubt that the owner, a Mr Brown, would be relieved to later discover it was safe and had very little damage, for balloons were very expensive and time consuming to manufacture.

The story was that at 12.30 p.m. Mr Brown had ascended from Beverley in North Yorkshire but found the wind too strong. He soon descended with great difficulty on Thorne Moor near Doncaster at 1.25 p.m., and there lay on the ground in a state of 'insensibility' for nearly two hours, due to the effects of the journey.

He was finally found and helped, but the balloon had in the meantime continued solo, until fortunately coming to rest at Swythamley, between Leek and Macclesfield, only 50 minutes later; a journey of at least 90 miles.

Silk

At this time many 'performers', for they were in effect superb showmen, were taking to the air. The experiments, begun in the late eighteenth century by the Montgolfier brothers, whose family were owners of paper mills near Lyons, had proved a great success. By November 1782 Joseph Montgolfier had created the first balloon of silk with an open neck and lighted paper beneath – a hot air balloon.

The following year the second foray was made even bigger with a circumference of 110 feet; a great advantage was the local important French silk industry situated virtually 'on the doorstep' at Lyons.

The race was on, and soon competitors were using hydrogen as the production of the gas improved, and being lighter than air it was considered a great advantage. It was also soon realised that it was better to use oiled silk, otherwise, when inflated, the hydrogen was able to percolate slowly through the cover.

Balloon Flights

The cars of wickerwork, strung below, became bigger and more elaborate as the size of the balloons increased, so that passengers, who were brave enough, could enjoy the thrill they had so generously paid for, in the company of the aeronaut.

It was not long before the Royal Society in London took an interest, and George III gave the idea of ballooning much encouragement.

Vicenzo Lunardi, Italian by birth, was soon on the scene. He was extremely gallant, very handsome, young and, of course, a great favourite with the ladies. He wore beautiful glittering uniforms, and on his first attempt from Chelsea Hospital endeared himself to the public by offering to divide the profits with the pensioners.

To cover the cost of the hydrogen, spectators paid a small fee to see the balloon exhibited as it was being constructed and inflated. The balloon was 33 feet in diameter and made of 520 yards of oiled silk in alternating gores of red and white. There were 45 cords running down from the netting, which covered two thirds of the body, and were secured to a wooden loop above the car as illustrated. The car was a simple affair; a rectangular basket also covered with netting, this would later become a fancy boat-shaped affair.

Lunardi was soon touring the country (see my previous article written about one of his escapades in Liverpool, which began on 20 July 1785 in *Past Times vol. I* page 75).

Although many subsequent aeronauts would die in their attempts to reach the clouds, or be seriously injured, the challenge would never fade as bigger and better balloons took to the air.

Charlie Green

With foreign encouragement, it was not long before Englishmen were attempting to satisfy their desire to fly, and in the not-too-distant future one in particular, Charlie Green, would be providing thrills and spills on his tour around the country, which did include Macclesfield.

Green was an unlikely character for someone who would become known as one of the greatest, if not the greatest, English aeronaut. Son of a London fruiterer, he joined his father in business on leaving school and from experimenting with coal gas to light his father's shop, graduated to the idea of using this cheap supply and easier to access source for filling balloons.

His first ascent, and the first for coal gas, was from Green Park in London on 19 July 1821 to celebrate the coronation of George IV. The balloon was decorated with the Royal Arms and named *George IV Royal Coronation Balloon*. It was said it managed a height of 11,000 feet and landed somewhat roughly in Barnet.

An Edwardian view, taken from Commercial Road looking up Hurdsfield Road, with the Gas Works to the left. Picture courtesy of Philip Oliver.

Green was a massively built man with a round friendly face, extremely talkative and lively, yet when he was heaven bound, his iron will, lightening quick reaction, calm and cool temperament all contributed to his skills as a superb aeronaut.

Accidents

He did have early accidents and once fell into the sea near Brighton. The most exciting was at Cheltenham in 1823 when someone managed to partially cut through the ropes undetected. As the balloon rose Green and his passenger suddenly realised the car was giving way, and quickly grasped the wooden loop below the balloon.

As the car and balloon parted company, the latter shot upwards at a considerable pace. Soon the mesh began to tear 'with a succession of reports like those of a pistol' and the balloon began to 'ooze out', taking on the appearance of a large hourglass. Still the pair clung on desperately for a considerable time fearing the balloon would escape the meshing, but at last, having lost sufficient gas it began a slow descent.

About 100 feet from the ground it suddenly escaped with a 'tremendous explosion' and was gone, the pair fell to earth and took a long time to recover. As is the way of human nature, this sort of event had spectators spellbound and drew even greater crowds at subsequent 'send-offs'.

Soon Green was travelling north, and by May 1827 had ascended from Ashton-under-Lyne and Chesterfield, advertising his intention to be in Macclesfield in a few weeks' time. Perhaps the unexpected arrival of the balloon at Swythamley, just one year earlier, had focused the attention of the public on the idea.

As usual a series of catastrophes had occurred at both Ashton and Chesterfield, which the paper meticulously reported ensuring a good crowd. And the advertising also helped, embellished with a drawing of the royal balloon called *Coronation* and the fact that it was Green's 73rd ascent – an incredible record.

Local Ascent

The flight was to be from the gas works in Hurdsfield using his 'improved safety balloon'. Tickets for the inflation and a view of the ascent were priced at 2s. For an extra shilling, and for the accommodation of 'Select Visitors [more particularly Ladies] Rooms in the New Silk Factory adjoining the Gas Works, will be fitted up with Seats commonly the most eligible view of the Inflation and Launch'. The gas company had purchased a site on the corner of Hurdsfield Road in 1819 (now the town yard), which was later recorded in the name Gas Road.

The balloon was described as 'splendid' and 'the most magnificent ever constructed' being the same one 'with which Mr Green performs his Nocturnal Ascents from the Royal Gardens, Vauxhall'.

It was constructed from 1,200 yards of the richest silk in alternating colours of crimson and gold manufactured on a 'new and improved principle'. Although the place of manufacture of the silk is not stated, some balloons were made from French silk, while others were from Spitalfields silk, there is no evidence to support the idea that any Macclesfield silk was being used in balloons at that period. It measured 110 feet in circumference and, together with the car, was 62 feet high. Not one of the largest to be recorded.

Lift Off

Early in the morning of Monday 30 June 1827 the inflating of Charles Green's balloon in the Gas Works Yard in Hurdsfield began. The advertising had been successful, and as the morning progressed crowds poured in from Congleton and Knutsford, and so great was the gathering that no one could remember anything to equal it.

The yard itself was soon full, and the balloon was filled by 2.00 p.m. The car was attached to the balloon, and the whole was anchored down by twenty weights of half a hundredweight each, but at times these were lifted off the ground.

During the morning a rumour spread that someone was going to accompany Green, but the identity of this person was kept a secret until after 4.00 p.m when Mr Grafton, the gas engineer, stepped into the car to give assistance.

Mr Green's son took another seat and his father stood in the middle, while a few minutes later the fastenings were released and the balloon rose 'magnificently into the air' amid loud cheers from the crowd.

It continued to rise in an easterly direction when unfortunately, having reached a height of about one mile, it disappeared into dense cloud – something of an anti-climax. Mr Green, reporting back later to the *Macclesfield Courier*, described the rest of the journey.

When they were about three quarters of a mile up they were picked up by a current of air coming from the north, which took them in the direction of Leek.

After about a quarter of an hour Green descended through the clouds to give the crowd in Macclesfield a good look at the balloon, now nearly over the southern end of the town. Within one mile of Leek the wind changed their course and took them over hilly terrain. They drifted slowly another 5 miles, passing near limekilns from which they could see the smoke rising.

After a flight of almost 2 ¼ hours they found themselves over meadows where green fences were ideal for the grapple, so they descended after a delightful voyage. Help was instantly given by men who had assisted Green the previous year when he had descended from the potteries, only two miles from that spot.

A local landowner, R. Gaunt Esq., sent several of his servants to assist and to give an invitation to the trio to attend a party at his mansion. There they met a large group of ladies and men formed to take part in a 'congratulations party' and enjoyed a 'sumptuous' meal.

This modern-day balloon, 120 feet high, circumference circa 220 feet, of rip-stop nylon and filled with propane gas, is almost exactly twice the size of Charlie Green's.

Repeat Performance

Another flight was intended from Macclesfield gas works on 3 July due to the great demand of those who did not attend the first one, but in the meantime Green was welcomed in Stockport and for a second time in Ashton-under-Lyne. Perhaps his 'improved safety balloon' deserved its appellation, because no crises or death-defying moments were recorded.

After a slight delay Green was again in Macclesfield on the 7 July. On that day many men and children dared to take a lift in the inflated balloon, securely anchored with ropes, to just beyond the top of the gas works wall. They had a lovely view of the River Bollin and the factory roofs. After paying a fee of either 2s 6d or 5s a princely sum for a working man, they went up three at a time with Mr Green, but some were very nervous, feeling sure the ropes would not hold. Yet many were happy to pay and Green reportedly 'reaped a rich reward'.

Charles Greaves of Hurdsfield volunteered £5 and expenses to travel back to town as a passenger, but Green objected because of his weight! The balloon took off at 10 minutes to 6.00 p.m. as an immense crowd filled all the surrounding streets and ten minutes later disappeared north of Buxton. It was seen there for an hour to the delight of the inhabitants and then had crossed the River Trent towards Lincoln. Hopes of landing on the racetrack were abandoned due to a current of air which took him south to Canwick House. He stayed overnight at the Saracen's Head in Lincoln before making his way back to Macclesfield via Buxton.

The Figgins' Academy

A row of cottages in Poynton today.

In a previous article relating to Revd Thomas Bullock of Sutton near Macclesfield, and his son of the same name, a character with a Dickensian sounding name, Francis Figgins is mentioned. In recent months he has more than once appeared during my research, and is now entitled to take his place in local history.

Although his father, John had married his mother, Hannah Leighton at St Peter's Church in Prestbury in March 1778 he, having been born on 27 May 1779, was actually baptised on the 17 June following at St Mary's in the town of Stafford, and seems to have been brought up there.

At present little is known of his early life, except that circa 1806 he had become involved with a private school in Poynton, by which time he would have been about twenty-six or twenty-seven years of age.

He is probably the person who married an Elizabeth Nabb at the parish church of All Saints in Glossop during February 1802. If this was his wife, she must have died because in his will, prepared some years later, he refers to his 'dear wife Ann Higgins'.

Poynton

At present one can only speculate that he was probably teaching in the Glossop area before his move to Poynton. There, however, his school seems to have been very successful, for on his subsequent move to Macclesfield he would claim to have been in Poynton for twenty-five years.

This is quite surprising considering that, initially at the beginning of the Poynton enterprise, the country was in the thralls of the Napoleonic Wars; trade had begun to stagnate, and the aftermath brought its own problems for several years with many previously successful businesses facing bankruptcy.

Still more surprising is the fact that Poynton was a busy little crossroads having grown up around the coal mining industry, nearby quarrying etc. which inevitably inspired the development of transportation links, with coaches, wagons and other vehicles very much in evidence.

Also, had Figgins been looking to the future and taken into account the necessity of an enlightened education system to complement the newly awakening commercial era, which had been in the process of expansion since the mid-eighteenth century, some sense could have been made of it. Figgins, however, was a traditionalist, and could only have been hoping for applications from the catchment areas of the Manchester and Stockport grammar schools.

Macclesfield

Within a couple of years of the birth of the Macclesfield newspaper he was advertising his boarding school where young men could be taught Latin, English grammar, writing and arithmetic. The fees were 24 guineas each year, this included the expense of the school books, and as an additional incentive 'no extra charge whatsoever' was being made for items such as the cost of the pupils' washing.

By July 1816, although the fees remained the same, an additional charge was added for schoolbooks and stationery, with three months' notice of withdrawal required. Figgins also suggested to prospective parents that should a reference be required, they should contact Mr Milner of Manchester, Mr Lowe a surgeon of Stockport, and Mr Samuel Hall of Macclesfield, whose children had been 'entrusted to him'.

Over the years periodic notices appeared giving the reopening dates for the new school term, and Figgins was at last catching up with the modern world, as evidenced by his advertisement of 20 December 1823. This confirmed the usual courses of classical and commercial education under his supervision, to which was added 'With a view of meeting the wishes of those who prefer knowing the total annual expense, to the charge of an uncertain number of Extras, every item is included in one Sum.' No fees were given but a reference and cards stating terms were available from Mr Goodwin of Chestergate, Macclesfield.

Syllabus

By the beginning of 1827 it would seem that at last Francis Figgins was fulfilling his ambition i.e. that of training the eldest of his three sons, John to assist him, presumably with the idea that in due course John would eventually take over the running of the Poynton School.

Francis announced that 'Penmanship and Arithmetic, the Greek, the Latin and the English languages receive particular attention' and were 'pursued to their origin'. The English education comprised grammar, composition, history and geography.

In the classical and mathematical departments he was assisted by his son, 'whose education and talents fully qualify him for the office he has undertaken'. The courses were exactly designed to prepare students for the universities.

'Mr Higgins assures Parents and Guardians … that his best exertions shall be used to preserve the Health, establish the moral character, and advance the literary attainments of his Pupils'. This reference to health was to become a recurring theme with Francis, and shortly his obsession, with the idea of fresh air, suggests that tuberculosis was uppermost in his mind.

Fees were quoted: under ten years, 6 guineas; ten-fourteen years, 18 guineas; above fourteen years, £21. There was an entry fee of one guinea and an extra one and a half per quarter for English, Latin and Greek. A further half guinea was added to cover washing and bed linen etc. and the usual three months' notice of removal was required.

All seemed well at the start of the New Year of 1828. The school seems to have acquired more pupils, despite the fact that this was the beginning of a great depression in the area thanks to Government legislation, which was greatly affecting the silk trade. Even the towns of Manchester and Stockport were beginning to feel the germs of rebellion in their midst.

Advantages

The school, due to reopen on 21 January now had an extra facility which Francis used to great advantage. 'In addition to local recommendations of Poynton as well calculated to promote the health of young Persons, the Pupils have recently had assigned to them a spacious, retired, and enclosed play-ground, in a dry and sheltered situation, with the privilege of playing at all times in Poynton Park, urestrained, except, by the presence of one of their Teachers'.

Both he and his son, 'aided by well qualified Assistants, direct their constant efforts to the improvement of the youth' committed to their care. The prospectus was at the academy with the same terms as previously, but the recommendation for references had now seen a geographical change.

Apart from the Macclesfield pupils, who had increased in number, the others were no longer from north of the town, but from the south. The three parents particularly mentioned were Mr Wild, a silk manufacturer of Rushton (Spencer), Hugh Wardle, a druggist of Leek and a Mr Ball of Froghall near Cheadle, all in Staffordshire.

Nothing is known of the school for the next two years, but in the meantime Francis must have decided to send his son John to university. The boy matriculated in June 1828 at Queen's College, Cambridge, to begin in the autumn at the start of the Michaelmas Term.

The course was normally three years after which a BA was conferred, and then a wait of three and a half years for the MA.

For some reason John received his BA after four years, for which there is possibly an explanation, but incredibly he never claimed his MA until 1870, almost thirty-eight years later!

Suddenly, during late 1830, Francis decided to move his school to Byron's Lane, Sutton near Macclesfield, adopting the grand title of 'The Byrons House Academy'. Unfortunately the building was pulled down in the early 1970s and replaced by a small select group of houses.

Byron's Lane today, the site of the former Byron's Academy.

Sutton

Whatever had made Francis Figgins decide to move to Sutton near Macclesfield, after being established in Poynton for twenty-five years, could possibly have had something to do with his health. He announced his intended removal just before Christmas 1831, which would take place during the holidays. He hoped that the patronage he had received for the past twenty-five years would continue, and that classics and mathematics would be taught by Mr J. L. Figgins BA of Queen's College Cambridge, who had been educated 'for the purpose of educating

others'. As there was no course at Cambridge to prepare students as teachers, his father could only have been referring to John's experience gained while he had taught in the Poynton School.

It would appear that he was facing quite a challenge. By 1828 there were already three 'Academies' advertising close by: Beach Grove, Macclesfield; Prestbury Classical and Commercial and Foden Bank Sutton. In fact the latter was only a little distance up the lane from Byrons, but on the opposite side.

Both estates had been part of the considerable Sutton Hall Estate, owned by Earl Lucan, and in 1803 a large sell off saw the Daintry silk family come into ownership of a considerable area of land, creating both the Foden and Byron estates for different members of the family.

Foden Bank, home to the Foden Bank Academy in the early nineteenth century.

Foden Bank

After Michael Daintry's death, his widow chose to live on in Byrons and his son J. S. Daintry at Foden Bank. However, due to a somewhat complex legal situation which arose after the will of 1810 had been proved, from 1823 to 1827 Foden Bank was leased to Thomas Brocklehurst after his marriage; he then removed to The Fence in Hurdsfield.

On 1 March 1828 George Magnus advertised his move from Etruria Hall near Newcastle-under-Lyme to Sutton, where his establishment was now the Foden Bank Academy. Magnus had been employed as foreign clerk at the Wedgwood pottery and from 1821 had leased the Hall. It was the former residence of Josiah Wedgwood who had died in 1795, but had been empty for some time. There Magnus and his wife advertised their 'Seminary for Ladies and Gentlemen'.

The advert of 1 March simply said that terms were to be moderate, and a limited number of day pupils would be received and provided with dinner at the boarders' table during the winter quarter at a moderate charge. The details could be obtained at the bar of the Angel Inn in the Market Place, Macclesfield.

On 3rd May it was reported that a few days previous Mr Magnus's schoolroom had been broken into and nine fur caps belonging to the pupils had been stolen. The thief was caught but he had already sold the caps to someone he had met in Mill street and they were still missing.

In December the terms were finally stated, 24 guineas for under fourteen years and 28 guineas for fifteen- and sixteen-year-olds. There was a small charge for extra tuition in English Grammar, Geography, History, Merchants' accounts, book-keeping both single and double entry, and

penmanship. Stenography was slightly dearer with Maths and surveying. The extra classes in Greek, Roman, Hebrew, French and other European Languages were the dearest at one extra guinea per term, presumably from Magnus's knowledge of foreign languages, in particular French.

His advert of June 1829 expressed his wish that all pupils were to speak French and there would be no extra charge in future for this language.

Mrs Magnus took in a limited number of young ladies to educate with her two daughters, and was assisted by 'a talented lady', with help from resident masters. Unfortunately by Christmas of that year a 'distressing bereavement' had occurred, forcing Magnus to announce that 'the Ladies school will in future be under the superintendence of Mrs S. M. Magnus a lady of superior attainments'. At the same time he stressed his intention to attend to the deportment of the pupils and every exertion would be used 'to remove provincial accent'.

No further adverts appeared for this school; it was gone as mysteriously as it had arrived. And this seems to have been the added incentive for Figgins.

Byron's House

By December 1831 Francis Figgins had completed the removal of his school to Byrons Lane from Poynton.

Byron's House was described as spacious and convenient for accommodation; the sleeping quarters were airy, and the bedrooms 'lofty, warm and well ventilated'. The playground, which gently sloped down on the west side, enjoyed the sunshine and a breeze, while to the north and east it was sheltered by the buildings and plantations, the latter of a mature age.

Francis pledged his continued care for the health, normal conduct and improvement of the pupils. He hoped that his friends would support the change he was about to make, as it promised to be very advantageous to him. The times of opening and terms were to be the same as those for the previous year, although not stated.

His eldest son John did not actually have his BA conferred until 1832, but, as he had completed the course at Cambridge, his father claimed this in advance. The delay was possibly due to the fact that because his father had declining health, John had been needed at home during the last few months to superintend arrangements, which could have been no easy task.

Copy of an invoice for the son of a local minister, who was a pupil at The Byron's House Academy, still signed by Francis Figgins in January 1834.

Francis's ambitions, however, were about to receive a blow, for John, having been ordained Deacon in 1833, almost immediately became curate of Linthwaite in Yorkshire, where he remained for two years until he became a priest in 1835. He then returned to Cheshire for a further two years, at Lymm with Warburton, before taking up a post at St Matthew's, Liverpool in 1837. Before that time, however, there would be no father to witness his later successes.

By Christmas 1833 Francis had become so ill that he had been force to retire from teaching, yet he still retained control of the school as evidenced by a bill for fees relating to Master Thomas Bullock at that date. As the charge for six months was only 2 guineas and the boy lived in Byrons Lane Sutton, he was obviously a day pupil. Judging from the previously referred to references, perhaps Francis had a better chance to fill his school with day pupils from Macclesfield and the neighbourhood, as the numbers of boarding pupils had decreased, hence the move from Poynton.

The other charges for Master Thomas were in total 17s 6d, relating to the use of reading books from the library, one sum book, lead pencils and rubber, writing books and paper, pens and ink, slip copied (6p) and fire (2s),. The latter was presumably to help pay for the coal used for the fire in the schoolroom.

Retirement

Determined that the school should continue, Francis made an important announcement to the public. After almost two years of ill health he felt it necessary to relinquish his role as head of the academy, a position he had held for thirty years. Now he had engaged Revd J. W. Bull MA, High Maste' of Clipston Free Grammar School, and his brother T. Bull, scholar of Catherine Hall, Cambridge, who were assisted by other competent masters to teach 'various branches of useful and polite education'.

Once the Bull brothers took over in January 1834, Francis and his wife returned to his beloved town of Stafford, but he retained ownership of the school.

Francis died on the 14 November 1835, but having recently bought the Byron's Estate, together with a piece of land described as 5 or 6 acres, left it in the hands of trustees for the benefit of his wife.

The former Modern Free Grammar School (known as the Commercial School) on Great King Street, which opened in 1844.

Bequests

In his will Francis Figgins, having left the Byron's Estate in Sutton in the hands of trustees, requested that all the household furniture be given to his wife. As soon as possible the area of land called the Moss Room had to be sold for the most money so the mortgage of £1,200 could be paid off, and any surplus money given to his three sons, John, Francis and William.

After his wife's death Byron's House and the remaining estate, and all the household furniture was to be sold for the most money and divided, after payment of any debts, among his sons. Meanwhile the trustees were to lease the estate and invest any money which accrued. Francis had already allowed the new headmaster J. Bull to lease the school property, which was now transferred into the hands of the trustees.

Professionals

Almost as soon as the Bull brothers had taken over the academy, they had 'been compelled to extend their accommodation for the reception of boarders', because of the considerable influx of pupils.

Another year passed and a professor of continental languages, proudly described as a 'Foreigner' who had been educated in French and German colleges which had prepared him for his 'Scholastic Profession', was engaged.

At last the school was flourishing – or was it? At Christmas 1836 a J. Woodcock, formerly of Oxford University, in his capacity as Head of the Academy, was setting out the usual details with regard to the facilities. Byron's Lane was a 'salubrious and romantic neighbourhood'; and again health and education were stressed. The Revd Bull and his brother were gone.

By the time he had completed eighteen months, Woodcock was giving 'grateful thanks' to friends and the public for their support and promising to continue his 'utmost exertions' in promoting health, religion and the mental abilities of the pupils.

Competition

For some time agitation had been growing in the town for the Free Grammar School (now the King's School) to invest in a separate 'Modern School', leaving the old building to continue with Classics. The act for this had already passed its third reading in parliament, and by June 1838 only needed the Lords to agree to the amendments of the Commons, before receiving Royal Assent and becoming law.

It would in fact be another six years before it finally opened its doors, after the usual procrastinations and controversies; but meanwhile it loomed in the background like the proverbial 'Sword of Damocles'.

At the same time the Prestbury Boarding School and Academy, under the direction of two distinguished academic masters, was also an additional competitor.

Still Woodcock continued on, his yearly adverts referring to his 'Highly Proficient Resident Masters'. But in September 1840 another surprising advert appeared and this time it was from a Mr F. S. Bradshaw, begging to inform the 'Gentry and Inhabitants of Macclesfield and its vicinity' that the partnership he had entered into with Mr James Woodcock of the Byron's House Academy had not 'been carried into effect'

He further announced that he proposed to open a 'select' boarding school and day school no less, and in only a few days. It was to be in the town of Macclesfield, and he trusted that it would merit the patronage and support of the gentry and inhabitants of Macclesfield and the surrounding area. He would give full particulars in a further advert.

Final Chapter

On 26 September 1840 the final chapter of the Byron's House Academy in Sutton was drawing to a close. Only three days later an auction took place on the premises of all the contents belonging to Mr Woodcock's establishment, including all the kitchen items. It was to be a considerable sale.

The most important items were twenty-seven four-post French and lower post beds with hangings; hair, flock and straw mattresses; feather beds, blankets, sheets and counterpanes, all obviously relating to the pupils quarters.

There were several items of mahogany furniture, bedroom chairs etc., presumably from the masters' rooms, and painted chests of drawers, dressing tables, washstands and chamber 'services' again from what seems to be the rooms, or room relating to the pupils.

The school itself offered up eight school desks, five large deal dining tables, 200 volumes of school and other books and a quantity of paper.

Even the dairy equipment was included, 'too numerous to list' the hurried advert read. The animals included two excellent cows; the dray-draught horse, suitable for harness or saddle; three pigs, a pony, poultry, hay etc. and finally a wheeled cart with iron arms and a nearly new hackney carriage.

At the same time an advert appeared from Mr F. S. Bradshaw, the original intended partner of Mr Woodcock, announcing that he had taken Westbrook House and was opening his school there on 5 October.

An original photograph of Westbrook House, courtesy of P. Oliver..

The only remaining part of Westbrook House in what later became West Park.

Westbrook House

This was the late residence of the silk manufacturer, Richard Wood Esq. and husband of one of Charles Roe's granddaughters Helen (née Nicholson). The stable building of this house is the only part still remaining in West Park. Bradshaw assured everyone that a Scriptural education would be provided 'deemed to be the basis of all other knowledge'.

By February 1841 boarders were being prepared for the 'Army, Navy, the Country House and Commercial pursuits' Saturday was devoted exclusively to religious education assisted by the 'clergyman' from the parish church. Classical studies were offered alongside modern subjects such as mapping, geography and bookkeeping.

Four months later it was announced that five pupils had received prizes and about this time the school closed for the summer break and was to re-open on 2 August, from which date Bradshaw decided he would no longer accept day pupils.

The following week produced an impressive list of names as contacts for references, mostly ministers of the church together with four worthies of Dublin. This could have been born out of desperation, or was there some other reason? Perhaps it will never be known, but scarcely had six months passed when the sale of 'Dr' Bradshaw's property took place by auction between Friday 26 and Monday 28 January 1842.

It was all 'truly valuable and modern Household furniture' including prime goose feather beds and bedding, kitchen equipment, other items such as 20 mahogany chairs, sideboard and dining table, carpets, rugs, curtains etc Finally the inevitable 'TO BE LET – WESTBROOK HOUSE' with pleasure gardens and gardens, with or without 17 acres of adjoining fields, appeared in the Macclesfield Courier for 7 May 1842.

In the words of Robert Burns (1759–96) 'The best laid schemes o' mice an' men, Gang aft a-gley'.

Macclesfield Coinage

A Macclesfield halfpenny with the design taken from Charles Roe's monument in Christ Church, Macclesfield, now administered by The Churches Conservation Trust.

The myth, that Charles Roe produced coinage at his smelt works on Macclesfield Common, has once more surfaced from years ago, and again the opportunity is being taken to correct this information; the real facts are far more interesting, as related in the book about his life *A Georgian Gent. & Co.*

When Charles died in 1781 he had established his own small group of companies, usually referred to as the Macclesfield Copper Co., which, although already successful in his own lifetime, would become even greater under the guidance of his son, William and the other partners.

There had been problems for years with the coinage, issued by the Mint which was housed in the Tower of London. This was the official coinage of the realm, and over the years, while the government concerned itself more with silver and gold coinage, the copper issues were neglected due to the dilapidated condition of the machinery there. More and more counterfeits were creeping into the market as the old copper coins became worn and deliberately chipped to retrieve some copper for melting down to help the forgers.

While gold and silver were essential, so were the copper coins in order that the greater part of the working population could be paid and could buy the necessities of life from individual shopkeepers. Some token coins, commissioned by those who had very large businesses, were accepted, because otherwise the government would have to buy the copper and then produce the coinage. That way the owner of the business paid, and the government avoided the expense.

Franchise

By the late 1780s the government was in a dilemma, counterfeit tokens were causing serious problems, and the only way to stop this was by a correct milling of the edges. The machinery at the Mint embossed the coins first and then milled the edges, but it was expensive to replace the milling machine for the halfpennies etc., and would be running at a loss. So, while the government was prepared to issue gold and silver coins, the manufacture of the copper coins was put out to tender.

Roe & Co. together with Thomas Williams, head of The Parys Mine Co. and the new lessee of Roe & Co.'s copper mine on Anglesey, but who had always run quite a separate business from the Macclesfield one, immediately put in tenders. However, Matthew Boulton, a Birmingham silversmith who had strong connections in the London market for his 'luxury goods', won the day and was given the legal tender for the copper coinage.

He brought in an excellent workman who milled the edges first and then passed them on to Boulton's workmen to be embossed. They were already producing beautiful expensive metal buttons, and the embossing of some of those was little different from that of embossing coins – except brute force.

It seems possible that one series of the 1789 Macclesfield tokens, sporting a beehive on the obverse side, were produced at the Macclesfield works, but immediately a friend wrote to Matthew Boulton, telling him to let the Macclesfield company know that he had been granted the government contract. From that time on, the series for 1789–1792 were produced by Matthew Boulton in Birmingham, with copper sent from Macclesfield; they were very beautiful coins and official legal tender.

There is an amusing letter from Boulton to a colleague saying the Macclesfield company had chosen as a pattern 'old Roe's head'! This was copied from Charles Roe's lovely monument in Christ Church, and in the year 1790 to 1791 alone just over two million were produced with this design, and there were several issues with other designs, especially for Ireland.

Opening of the Macclesfield Canal

A stretch of the twenty-seven-and-a-half-mile-long Macclesfield Canal, as it passes the inn formerly known as 'The Fool's Nook' in Sutton.

On Wednesday the 9 of November 1831 the town was full excitement as it was the day of the opening of the Macclesfield canal. This now brought a strong ray of hope for the future.

The silk trade had suffered greatly since 1824 when Huskisson's free trade policy had encouraged a flood of silk imports, particularly from France, which had devastated trade in areas such as Macclesfield.

The canal, which originally should have been one of the earliest to be constructed in the country, finally became one of the last before the great railway age began. It had taken almost sixty-five years for the dream of the original enthusiastic Georgian promoters, among whom Charles Roe of Macclesfield had played such a prominent part, to become a reality.

The early days had been a struggle. In 1765 the Duke of Bridgewater was already planning yet another scheme in the northwest, intent on becoming the greatest canal builder in Europe. Josiah Wedgwood was drawn into the plans, and due to both his and the Duke's self-interests, the branch intended to link Macclesfield ultimately with Liverpool, never transpired.

Bitterly disappointed Charles Roe and his colleagues threw their support behind a River Weaver scheme, and sent their goods via Northwich and the River Mersey to the port of Liverpool. Roe & Co. then built a copper works in Liverpool and Charles sent his eldest son, William, at the age of twenty-one years, to superintend that part of the business.

The canal idea once again surfaced in the early 1790s. By that time Charles had died and it was left to son, William and the company to enthusiastically support the scheme, which they did by buying ten shares. In August 1796 another partner was authorised to double the canal subscription should further funds be needed.

Enclosure

In this same year an Act of Parliament was passed allowing enclosure of Macclesfield Common. This meant it could be divided up and auctioned off in lots, apart from those retained for the sovereign as compensation and those reserved for Macclesfield Corporation, which incorporated the water supply to the town etc.

Everyone who was anxious to buy 'their own plot' now had two options for investment. Part of the canal was to be constructed across the Common, which would benefit those who held land in the area. The copper company smelters, already established adjacent to the proposed route since 1758, would greatly benefit, so the company bought eight lots and William several more.

It was in everyone's interests to buy the land first and then encourage the building of the canal, that way it was a valuable investment, ensuring an increase in the value of their land purchases. However things were not to be, the French Revolution of 1793 was already casting a shadow over Continental Europe, and Napoleon's rise to power with his blockade of ports against British goods, saw the United Kingdom in complete economic crisis by the late 1790s.

There was no money for canal building, as longer and longer lists of bankrupts appeared in the newspapers, it was needed to supply the army and, at this point in particular, the navy for our defence against Napoleon's intended invasion, which was an ever present threat.

Finally with the war over in 1815 and commerce regaining its former position in many areas, the silk trade, which had managed quite well to survive apart from the inevitable odd periods of depression from time to time, never considered that within a decade it would be turn onto a course of almost complete annihilation.

The Canal

The Macclesfield Canal scheme had been revived as early as 1824 when, in September of that year a public meeting was held at the Macclesfield Arms. After government promises on silk tariffs, local manufacturers had invested heavily in new machinery and expansion; an extra transportation system was now urgently needed.

Coal, in great demand for steam engines, saw Poynton and other local collieries hardly able to satisfy need, so supplies from North Staffordshire were essential.

Cotton had also become an important addition to the town's manufacturing industries, and it was of necessity that these, and other bulky raw materials should be conveyed by canal.

A month later the bankers Daintry and Ryle were appointed treasurers, but a subscriber wrote, complaining that investors had not been consulted about the issue; also the Act of Parliament, the necessary sanction for the scheme, had yet to be passed.

Finally in March 1826 the bill received its third reading and was passed, but

Part of the Macclesfield wharf with the building once noted for its Hovis bread, but now converted into flats. The original wharf was said to be on the other side of the bridge.

by then the town was in the middle of the worst depression it had ever known, with 15,000 unemployed and 10,000 dependent on charity.

For once this seems to have spurred on construction, for many men would be available for labour, although as work progressed it did encourage an influx of Irish labourers to the area, sometimes with unfortunate results.

The First Steps

The question of treasurer had still not been satisfactorily resolved, until another meeting at the Macclesfield Arms hotel early in May 1826. John Daintry then proposed Edward Smyth, owner of Fence House and its estate in Hurdsfield, but Edward Stanley, brother of the Liberal MP Sir John Stanley of Alderley, said that a banker would be best for the position, and proposed William Brocklehurst, which was seconded by the important silk manufacturer and also banker, John Ryle.

William, however, suggested someone else be chosen, so another committee member instantly chose Thomas, William's brother, who was a partner also in their bank; this was accepted by everyone.

Just one year later the canal project was reported as being well in advance, and finally in 1831, with the end in sight, the opening was planned for 30 August. The event was in fact delayed until 9th November due to concern regarding the embankment between Congleton and Bosley.

By that time of year it was concern for the lady guests, because of the detrimental 'atmosphere' which could affect their health, that now took over, so they had to be content with a view from the windows of the newly erected corn mill at Macclesfield wharf, where sacks of flour had been removed for their benefit.

Grand Opening

The canal company's two largest barges, the 'Macclesfield' and 'Congleton', handsomely decorated, were reserved for committee members, with refreshments on board. With the ladies absent one might assume the 'gentlemen' enjoyed a little more than 'afternoon tea'. Two processions of boats, one from the north comprising twenty-five vessels, and one from the south of fifty-two, were timed by signals to arrive at about the same time.

There were gun salutes, cheering all the way en route, bands, banners and everything else to make it a memorable day, In particular the committee and invited guests, numbering about 200, having been preceded by the Cheshire Yeomanry band, walked from the wharf to the Guildhall where a grand dinner, served in Mrs Foster's 'usual superior style' took place.

She was landlady of the Macclesfield Arms and also catered at the guildhall for the Corporation. Renowned for her catering abilities, as witnessed by frequent mentions at that period, many a grand dinner and 'jovial' evening were credited to her account.

Mrs Foster

When considering Mrs Foster's famous catering credentials, resulting in 'sumptuous dinners' both at the Macclesfield Arms and at the guildhall, the question is how she manage to ensure that the course of hot dinners were indeed hot when being served in the latter building.

Her ability to supply the choicest of wines, which is also referred to on occasion, would be no problems. Even the soups and sauces could be carried quickly across the top of Jordangate to the Market Square (as it then was), and on arrival in the guildhall and subsequent new town hall, could be ladled out into large tureens or sauce boats; also the sweets and fruit would present little difficulties. But the roast beef and vegetables could have been problematical if it wasn't for the ingenuity of the Staffordshire potters.

Presumably the roast beef, which was very popular, would be taken and carved by the Foster entourage in the room where the beautifully laid out tables had already been prepared. Gaslights

were already operating in the town hall, and in preparation for a grand charity ball for the poor and unemployed in January 1827 the building had been 'thoroughly painted and aired'.

The assembly room in particular was the subject of great attention, where three large chandeliers, specially made to complement the new décor, were suspended from the ceiling with six side branches each, in all emitting 800 gas lights. On that occasion, because of the ball, an adjoining room was set out for card parties and refreshments.

With the new revolutionary gas lighting, and even when candlelight prevailed, the table displays were as important as the food, and probably more so. The lighting would have accentuated the gold decoration and vibrant colours of the dinner service complete with exquisite tureens, sauce boats and stands, elaborate comports, figurines, fine drinking glasses and the like. There is no doubt that the scene would have been one of great splendour.

The Pottery

Formal dinners on a grand scale were very much in fashion from the Regency period, and the pottery manufacturers had not been slow in taking advantage. Some, like the Spode factory, had actually created hot plates, which were used in the same way as stone hot water bottles. Some were the same size as dinner plates and others larger. They were in effect a two-tier item, as though a soup dish had been covered by a dinner plate of the same diameter, and the two then sealed around the edge.

The plate had a very small round aperture close to the edge, which permitted boiling water to be poured in, thus filling up the space or well created by the bowl; a small stopper was then inserted to seal the aperture. This, of course, had the effect of keeping the plate warm for quite some time, and with the larger version complete with cover, possibly of silver for the grand occasion, food could be taken from the kitchen to the dining hall still hot, from which the various serving dishes could be filled.

These hot water plates were not only useful in ancestral homes, where the distance from the kitchen to the dining room was often some distance, but also in public places. And Mrs Foster and her staff would be able to transfer the hot dishes from her kitchen in the Macclesfield Arms to the Guild or town hall in suitable manner.

Vegetables and fruits of considerable size were frequently mentions in newspaper reports, and pineapples were an incredible luxury, with their own special stands created to allow them to take pride of place in the centre of the table.

Festivities

As regards Christmas festivities at that period, surprisingly early nineteenth century newspapers reveal little about the actual celebrations in Macclesfield, but are full of all sorts of activities such as Corporation meetings and business matters taking place up to Christmas Eve and even on Boxing Day.

With the arrival on the throne of young Queen Victoria in 1837, and her subsequent marriage to her German cousin Prince Albert, the real story of our present Christmas celebrations begins. With typical German enthusiasm for commemorating the birth of Christ, Albert added a whole new depth of meaning to the festive season. The Christmas tree in turn inspired a more creative market for presents in remembrance of the Three Wise Men, and the creation of the Christmas card.

Index